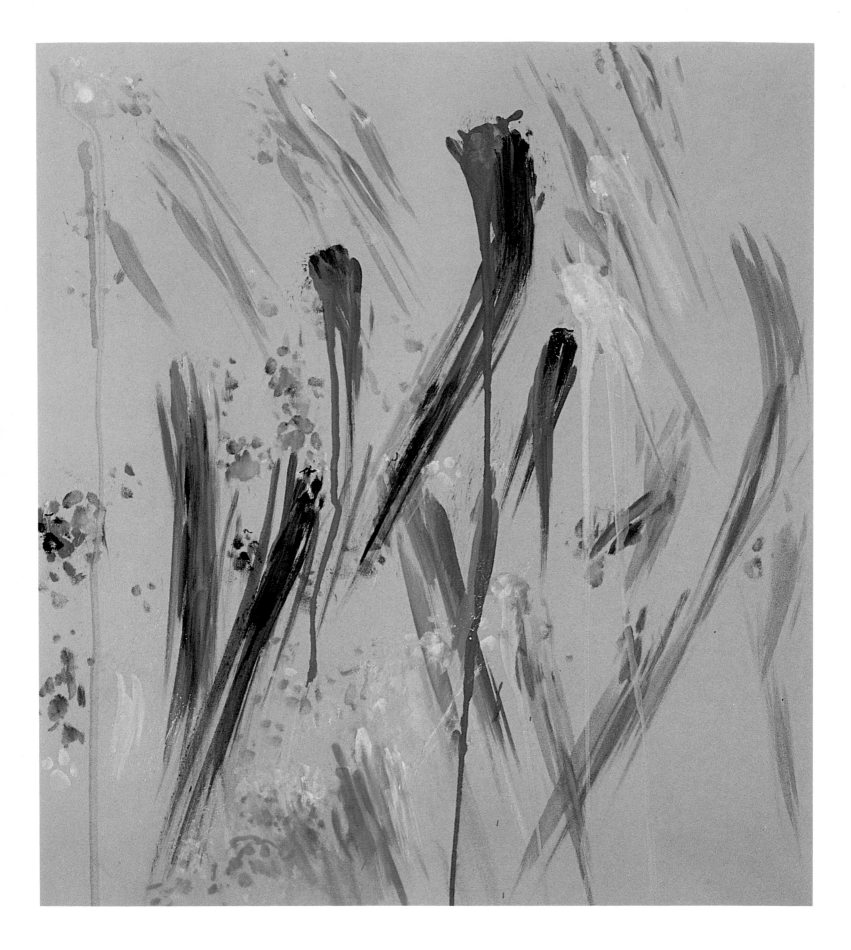

WHY CATS PAINT

A theory of feline aesthetics

Heather Busch

Burton Silver

Ten Speed Press Berkeley, California

"In order for something to be so, we first have to think it."

Albert Einstein

1☺

TEN SPEED PRESS
P.O. Box 7123,
Berkeley, California 94707

Library of Congress Catalog information is on file
with the publisher.

ISBN 0–89815–612–2

Photographic assistance by Martin O'Connor and
Annelies Van Der Poel.
Technical assistance by Ian Biggs and Kriss Rose.

Typographical design: Trevor Plaisted.
Editorial direction: Melissa da Souza-Correa.

Originated, devised and designed
by Heather Busch and Burton Silver.

Compiled by Silverculture Press,
487 Karaka Bay Road, Wellington 3,
New Zealand.

Why Cats Paint is a registered international exper-
iment in inter-species morphic resonance and is
designed to test the hypothesis of formative
causation. I.E.# 644-38837-59.

Printed and bound in Hong Kong.

5 – 98 97 96 95 94

Frontispiece:
Orangello, *Beam Me Up,* 1982. Acrylic on
yellow card, 48 x 68cm. F. Norbert
Collection.

TABLE OF CONTENTS

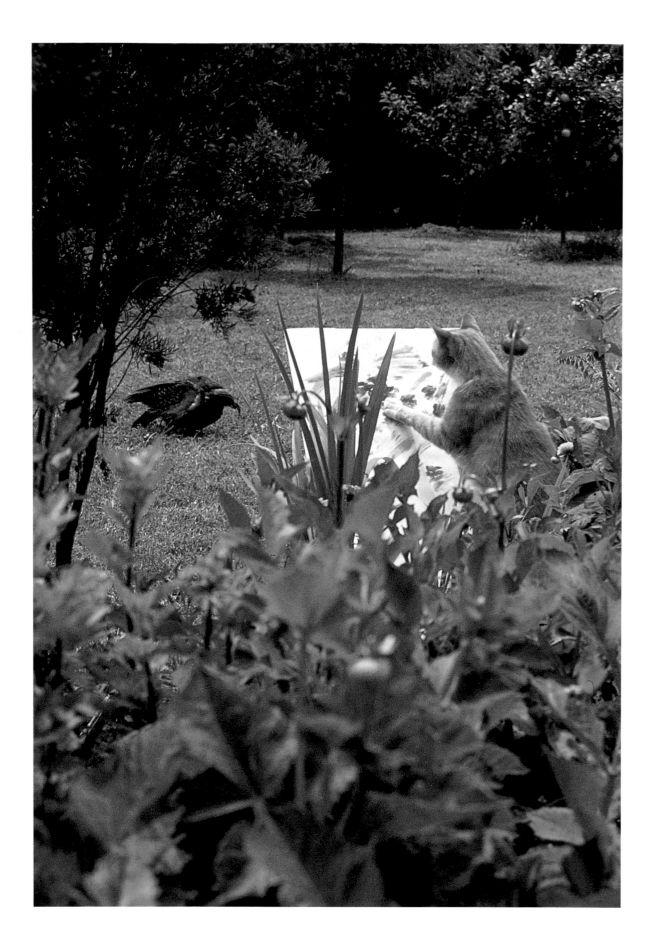

FOREWORD

My late husband, Dr. Arthur Mann, has been credited with the discovery of representational marking by domestic cats but I don't think he'd mind me telling you that he was given crucial guidance by a couple of three year olds. One, a beautiful ginger tom called Orangello, the other, an equally beautiful little girl called Francesca.

In 1982, Arthur was staying with Orangello's owners, the Norberts, in order to study their cat's prolific marking behavior as part of his thesis on Feline Territorial Demarcation Activity. The walls of the big studio were festooned with Orangello's colorful works, each one carefully labelled as to where and when it was done, the medium used, the time taken, and the ratio of verticals to horizontals. But after five months, he was no closer to any coherent explanation.

It was the Norbert's three-year-old daughter who broke the code. Lying on the floor one afternoon, sucking her bottle and looking back over her head, she pointed at a painting and said, "Moo-cow!" And, "That moo too!" Later in the day, when she walked back in, Arthur playfully asked her to point out the moo-cows again. At first Francesca just stared blankly, but then, twisting her head round to look at the pictures upside-down, she quickly identified them both. Intrigued, Arthur tried doing the same and was amazed to find crude but recognizable images of familiar objects in the house, like the large wooden cow that was used as a door-stop. Orangello was painting real things upside-down!

At last, cat painting could cease to be dismissed as some kind of instinctive territorial marking behavior and begin to be seen as a pre-planned communication. Just what that communication is and what the motivation behind it might be, can still only be guessed at. Had someone taken over my husband's research when he died, I feel certain we would know a lot more than we do today. But perhaps Orangello provided us with a hint in his last major work, *Beam Me Up* (see frontispiece*)*, which he painted the day after Francesca's little toy Scottie dog was irretrievably lost down an old well. To us, it is a lyrical and well-balanced work, suggestive perhaps of flowers on a spring day, or an after-banquet fluttering of peacock feathers, but to Francesca, who lost no time in looking at it upside down, it revealed the unmistakable pointy ears and snub nose of her beloved Scottie.

Nora Mann

Left:
Orangello pauses during an invertist painting of dahlias to observe a tame parrot, which has just landed. While Orangello did not chase the parrot, he was obviously put off by its presence and later destroyed the work with obliterative lines. This strongly suggests the painting was a mood piece rather than a representational work. Either way, it represents a great loss given that photographically verified cat paintings can fetch prices in excess of $15,000.

PREFACE

Can you see the cat's tail? We so seldom consider the feline origins of the question mark that this old written riddle still puzzles children and adults the world over. Cats use tail signals to indicate their changing moods and perceptions, and because ancient civilizations accepted that cats had special knowledge, these signals were considered important and incorporated into the earliest forms of calligraphy. Thus, the classical curled-over tail of the curious cat is still found in most of our written texts as the symbol used to denote a question. It is our hope that by exploring the signs a small number of domestic cats continue to make today, we may rekindle an interest in their unique way of perceiving the world and perhaps derive valuable insights from it.

We are well aware that we can never communicate with cats, or they with us, on anything like the level we can with members of our own species. While great strides are being made in teaching dolphins and chimpanzees to recognize and respond to our commands, there still remains an enormous gulf in understanding. This is not helped by the fact that almost all attempts to analyze the way in which animals perceive their environment have been undertaken within a strict scientific context.

While readily admitting to the value of such study, it is the contention of this book that we may discover more about the perceptions of the domestic cat by examining its marking behavior within an artistic rather than scientific framework. According to biologists for example, human art arose out of man's early need to mark his territory and possessions in order that his ownership could be asserted and recognized by others. In support of their case, they point out that art is almost never considered on its own merit without taking into account the name of the artist. So whether it be graffiti in a subway or a retrospective at MOMA, art is described by biologists as being simply the end product of man's strong individual desire for status and acceptance within the group.

When you consider how much more art is than that, and what it has done to benefit mankind and tell us about the world, you will understand why we do not wish to allow our perception of cat painting to continue to be limited by an exclusively scientific analysis.

While theories on the aesthetics of non-primate signing are hardly new, we are aware that the great popularity of the domestic cat as a pet means any attempt to describe their marks as art carries with it certain dangers. The growing commercial value of cat art for example, has led not only to some misguided breeding programs (notably with Persians in Australia),

Above:
The classical curled-over tail of the curious cat which gave rise to our question mark, right down to the dot at the bottom.

but also to a few, thankfully rare cases, where cats have been trained to 'paint' for reward. To the expert eye, the resulting works inevitably lack any integrity and are easily spotted, but, because they can be photographically verified, an increasing number are creeping onto world markets and being snapped up by gullible cat and art lovers alike. These sort of practices may promote tremendous public interest and debate but, in the end, they have a negative effect, and the potentially important messages inherent in each work are lost sight of amidst the clamor for commodification.

Because cat paintings can be so joyous and full of life, it is only natural that a great number of people will want to enjoy them. To this extent, commercialization of cat art is inevitable, and already motifs from cat paintings have appeared on fabrics, wallpapers, pottery and the like. It is now crucial we do not allow a wave of popularity to diminish the importance of cats' work and tempt us into removing it from the art context, where it can receive the serious study and protection it so richly deserves.

While we hope this book will inspire readers to carefully examine paw patterns in litter trays for examples of aesthetic intent, or leave a bowl of damp marking powder out by the refrigerator in case their cat may wish to express itself artistically, it is not our intention to give instruction on methods of encouraging cats to paint. This ethically difficult area is well covered by other texts listed in the bibliography. Nor is it our intention to provide detailed information on materials, techniques or compositional analysis. Evidence of one-point perspective in cat painting for example, is more appropriately the subject of articles in such journals as *Cat Art Today* or better dealt with in the excellent displays on feline perception at the Museum of Non-Primate Art in Tokyo.

Finally, we wish to acknowledge our debt to Specieism—that school which presumes aesthetic intent for the movements, marks or sounds of another species and then sets about interpreting them, without prejudice, in the hope of gaining new insights.

It is our belief that all species on this planet have an equal right to self-determination. As human beings, we must suppress our desire to see cats confirming our perceptions and values through their 'art', and, rather than attempting to determine the direction of their aesthetic development on our terms, we must allow those few cats who paint to develop their own special potential. Only in this way can we be certain they will be able to communicate their unique, undiluted view of the world and perhaps provide us with the clues we need to ensure the survival and future well-being of all species—provided of course we can trust them to tell us the truth.

Heather Busch and Burton Silver,
Wellington, 1994.

INTRODUCTION

One spring morning in 1978, two weeks after a discussion with a rather conservative colleague on what does and does not constitute a work of art, we received the snap shots you see printed below, of a cat 'painting' on a Russian television program. Accompanying them was a rather caustic little note saying, "I suppose this is art too, is it?" This was our introduction to the possibility that cats might actually be able to paint and we were all intrigued. Even for a trained cat, the designs showed a remarkable symmetry and certainly displayed that fundamental requirement of any art work—a potential for meaning.

On his return from Moscow we plied our colleague with questions about the cat, only to discover he could remember little of the program and, not being able to understand Russian, had no idea what it was about. He had simply taken the snaps in a fit of pique one night in his hotel room and didn't know whether the item was filmed in a laboratory, if a trainer was present, what night he'd seen it, or even the brand of vodka he'd been drinking. Our attempts to get information out of the Russian Broadcasting center at Ostakino met with a 'neyt' response and then, just when we were ready to give up, a friend remembered a letter to the *Folkestone Star* about a cat who did paintings on kitchen cupboard doors.

Thanks to the *Star's* excellent database facilities, we found the letter, written by a Mrs. M. Smith of Canterbury. Many phone calls later, we were actually speaking to her. Unfortunately, her Muffy had died three years ago, but some of his paintings were still on the wallpaper in the hall and her friend had a ginger tabby who did some very interesting designs on the refrigerator now and then. We would be welcome to come down and have a look. Seven of us crammed into Mrs. Day's kitchen the next weekend was far too much for Tigger. He wouldn't even come into the house,

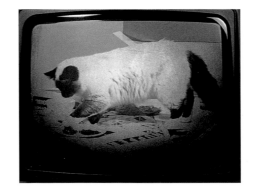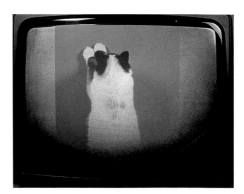

let alone paint. But three weeks later, with just two of us present, we were rewarded with a brief yet spellbinding display of his artistry.

Tigger began by staring at the white door of the refrigerator for several minutes before stepping up to one of the saucers at its base and carefully brushing his paw pads lightly over the surface of the thick paint it contained. Then, perfectly balanced on his hind legs, he reached up and made the most delicate comma-like swirl of blue just below the handle. He repeated the motif three more times in different colors, one below the other, and then, with scarcely a glance at what he'd done, nonchalantly walked outside to wash his paws. The whole operation lasted only a few minutes but had been performed with such casual grace it appeared as if nothing unusual had occurred at all.

Many people have similar feelings the first time they see a cat painting. It seems such a perfectly natural thing for it to be doing that it is not until later they think to examine the cat's motivation—and when they do, the questions come tumbling in. Is it trying to represent something, an object maybe or perhaps an emotional state, and why? Could it be trying to communicate with us or another cat, or is painting a way of exploring its inner feelings? Do some cats actually have an aesthetic sense or is their 'art' simply a form of territorial marking behavior, as many biologists believe? We are much closer to finding the answers to these questions today than we were when we first saw those photographs fifteen years ago. A great deal has since been discovered about cat painting and we hope that sharing some of this knowledge with you now may give you insights that could help find solutions to the many mysteries which still remain—grinning down at us out of the branches above.

Below:
This cat (almost certainly a Birman), appeared on a Russian television program in 1978. Little is known about Russian cat painting generally and nothing is known about this cat in particular, except that the remarkable symmetry of its designs show it to be a highly advanced painter.

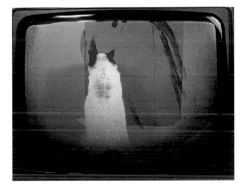
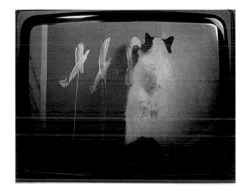
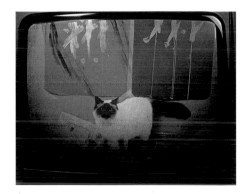

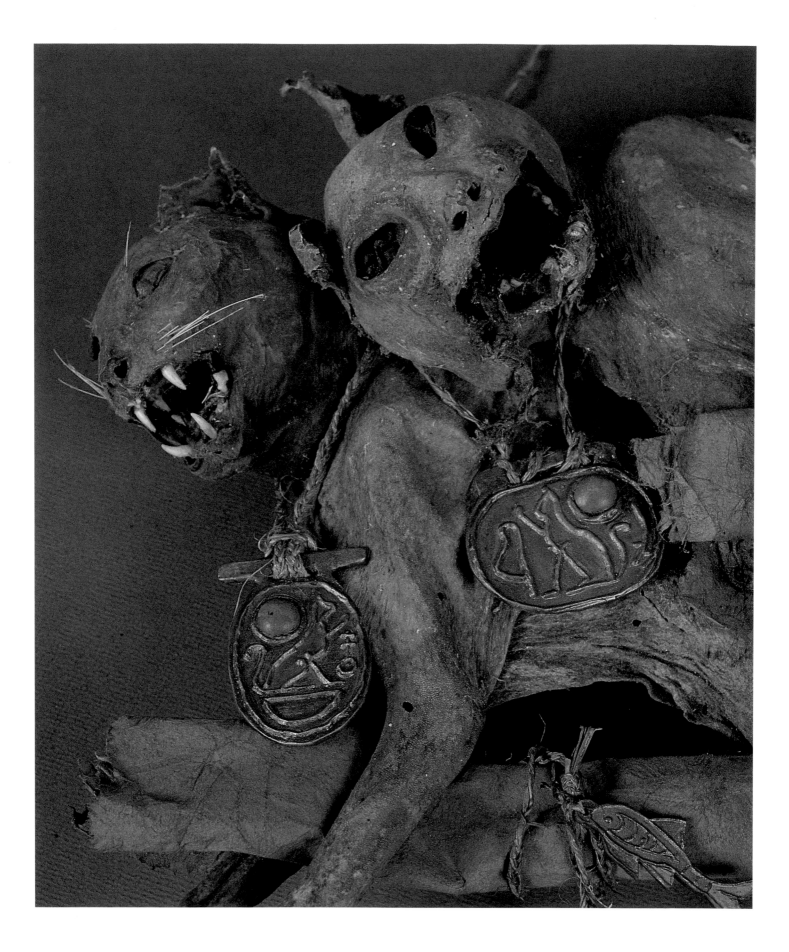

Chapter
1 | An Historical Perspective

In 1990 a dramatic discovery was made by an Australian archeological team working in the tomb of Vizir Aperia, just beyond the west bank of the Nile. Hidden for five thousand years in a previously unopened burial shaft, they found the embalmed and intertwined bodies of two female cats, Etak and Tikk. What was so exciting for Professor Peter Sivinty and his team was not the unusually ornate bronze and gold pendants that adorned their necks, nor the remarkable state of preservation of their non-mummified remains, but the fact that between the forelegs of each animal was a carefully rolled funerary papyrus containing the clearly visible marks of a cat's paw. These are the earliest known paintings by a domestic cat and the first conclusive evidence that cat-marking behavior was known to the ancient Egyptians and considered by them to be of spiritual and aesthetic significance.

The discovery of the Aperia Cats led to the immediate re-examination of other feline remains in museums round the world and resulted in a number of other funerary scrolls being found to contain barely discernible paw prints. Where these had previously been noticed they were usually dismissed as dirt or, in one descriptive paper, as "Single vertical smear (2.5 x 31.5cm) of excess embalming oil."[1]

But why were their paintings so simple? Why did they comprise of only one or two strokes compared to the far more complex paintings domestic cats are able to undertake today? The most likely explanation comes from Professor Sivinty himself. Writing in his book *An Epistemology of Cat-marking in Ancient Egypt,* he says, "...the cat of those times was probably just as capable of elaborate marking as our modern day cats, but as they were regarded as the medium through which the gods expressed themselves on Earth, it would have been seen as inappropriate for them to make a messy confusion of marks. What was required by the priesthood was a simple, unequivocal mark of authority. It seems most likely then, that once the cat had made its first one or two strokes, it would be considered to have finished and both the scroll and paint would have been removed." This view is supported by the Lapis Lazuli funerary scroll (right), where the cat is shown making a very bold paw stroke with great

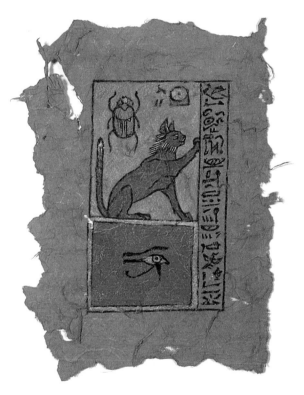

Above:
Funerary Papyrus of *The Lapis Lazuli Cat,*
Bodhead Library, Oxford.
Note the upright tail position of the painting cat, signifying its pleasure and therefore approval of the hieroglyphic text.

Left:
The Aperia Cats, c.3000 BC, holding scrolls, (Etak left), Phakat Museum, Cairo.

[1]Crighton, A. Five Feline Funerary Figures. *Journal of Creative Egyptology, Vol.44, 1951.*

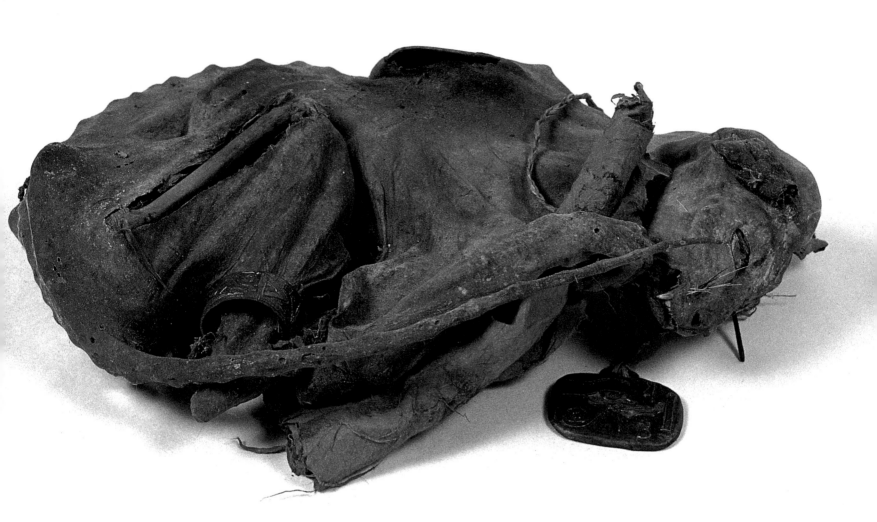

confidence from a position directly above the Udjat, symbol of the all seeing eye. Cats with their paws raised were always thought to be making the sign of Ra, god of the sun, but it is now clear that they are painting and the image of a painting cat is generally recognized to be a sign of celestial approval for the inscriptions on the scroll.

Some studies have suggested that the hieroglyphics on feline funerary scrolls may have been an explanation of the cat's painting, but written at a later stage by the priests. In the Xois scroll for example (page 15), we read, "...free us from the burden of questions, our trust goes forth without questions." Given that the curious form of the tail is so clearly represented in the cat's painting and then negated by a diagonal, it is argued that these words are too appropriate not to have been added later.

However, tempting as it may be to interpret them as one of the earliest known pieces of art criticism, there are several places where the cat's painting medium has clearly overlaid the human inscriptions, thus proving that it post-dated them. Indeed, if further evidence is needed that cat's marks were applied as a seal of approval, it can be found in the famous wall painting at Deir el Medina (page 16), where the cat's mark is clearly affirming of the propositions outlined in the hieroglyphic text.

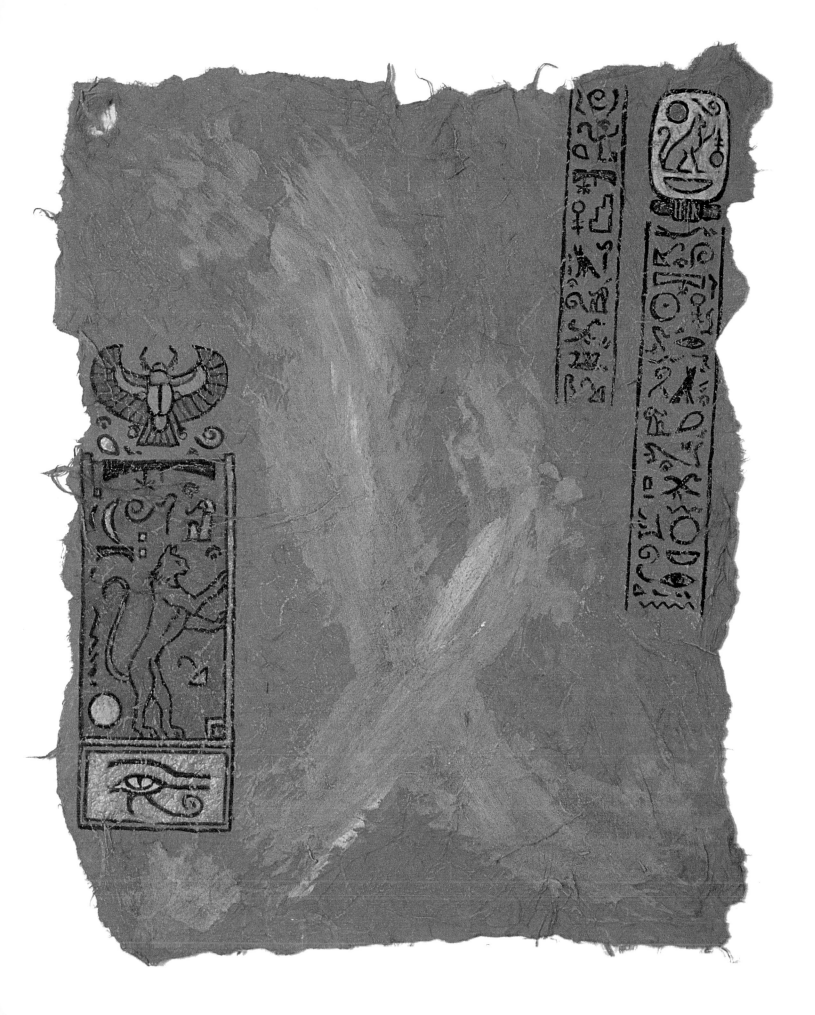

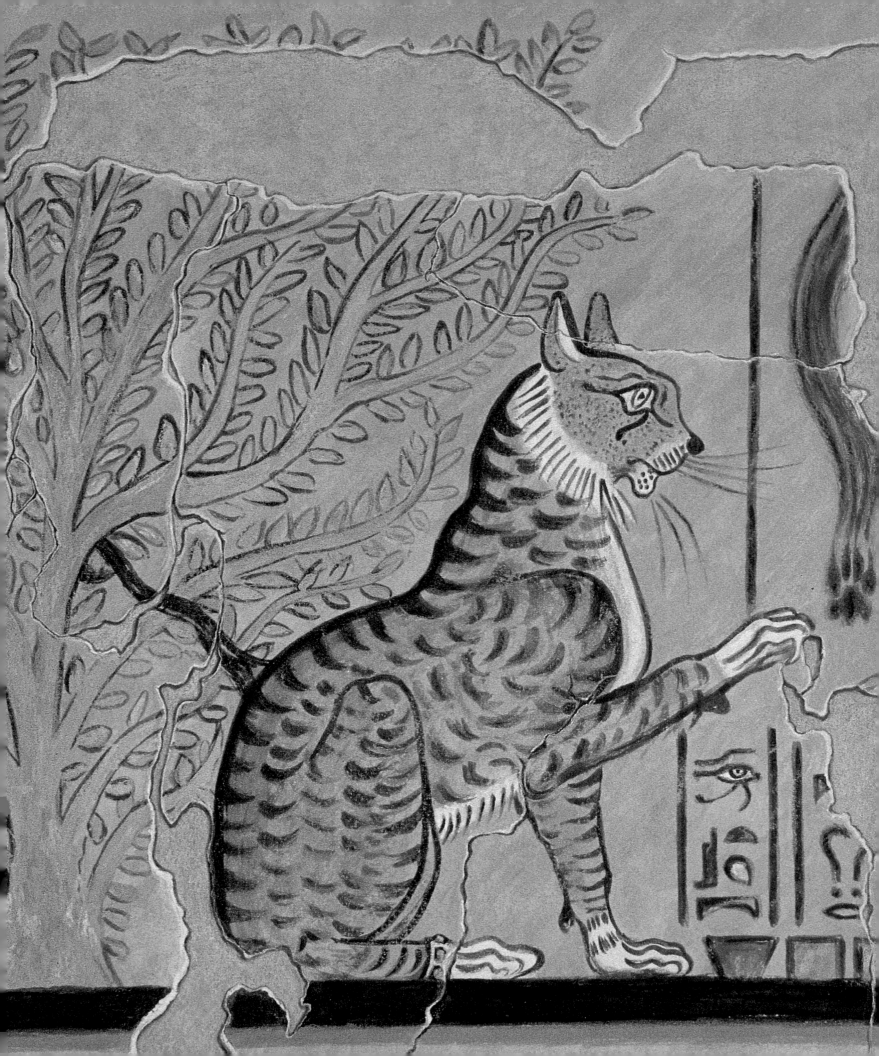

a.

b.

c.

d.

Left: (a). The Udjat represents the all-see-ing eye which can penetrate the higher spiritual realms that are unavailable to human beings. This symbol is often con-nected with the cat and can be seen in various forms on the scrolls and pendants shown in previous pages. Note that the eye of the painting cat is in the form of the Udjat.

(b). This grouping of symbols represents the Ebut or painting apparatus used by the cat. The two rounded shapes stand for two different colors of paint. To the left of them, the L shaped symbol represents the combined easel and paint tray or Lex. Underneath is the stool or Poot on which the cat sits while painting. The Ebut signifies the means of affirmation.

(c). This is the Punkut which incorporates the dual sign of the curled-over tail above the oval symbol of Ru. Ru represents the cat's eye, doorway to the spiritual realms. The Punkut stands for the counterbal-anced psychic perceptions of two cats, a kind of Yin Yang of spiritual inquiry.

(d). This almost totally obscured symbol is the Nildjat or "the contemplative cat who sits peering into the hidden realms of the spirit world." The Nildjat represents the triangular form of the cat when seated in the contemplative position with the tail held in the inquiring mode.

Far left:
A reproduction of the tomb wall painting at Deir el Medina, c.1250BC. Here the sun god Ra in the form of a cat completes what is almost certainly the sign of the curled-over tail and paw dot. This signi-fies spiritual inquiry and perception of the inner world. The cat's painting affirms the hieroglyphics below which propose that inner perceptions are better confirmed by two cats rather than one.

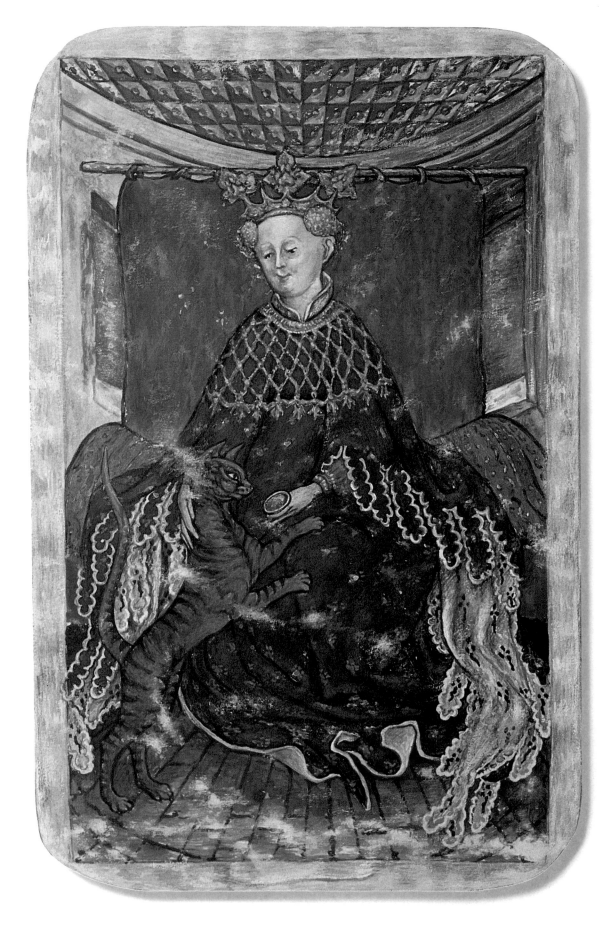

Right:
German story card depicting the White Queen and the wicked cat, Betrug, c.1430 AD. Katzen-Kunst-Museum, Stuttgart, (Room 17, third floor, case 5, exhibit 8.3). The cat seen here making marks on the Queen's robe with her rouge, is the only animal in German folklore able to make meaningful marks. Even animals imbued with magic powers always change themselves into a cat before marking. Betrug is really a bear (see text).

There is little recorded evidence of cats marking between 1000 BC and the Victorian era, other than a few examples during the Middle Ages when cats became associated with witchcraft and were killed in their thousands. Throughout history, cat behavior has been interpreted according to the beliefs current at the time, so once cats fell from favor their scratch marks and paintings, instead of being seen as messages from the gods, were taken as signs of the devil.

We find a graphic example of this in an illustration on an early German story card (page 18). Here we see the White Queen with her arm draped lovingly round the cat, Betrug, who is making marks on her robe with his paws. The mediaeval artist has left us in no doubt as to Betrug's character. His piercing eyes and pig-like nose give him a grotesquely evil demeanor, in stark contrast with the smiling and trusting expression of the Queen. In this old folktale (recently made into an opera by Kurt Pries), the Queen sends her cat out in pursuit of a wicked bear who has captured her daughter. The unfortunate cat is crushed to death by the bear, who then cleverly returns in the guise of the cat and tells the Queen her daughter has been imprisoned in a vast stone labyrinth. By wiping his paws in her rouge he is able to mark out a false plan of the labyrinth on her robe so that she will attempt to find her way through the complex of corridors and fall into a trap as she searches for her daughter.

Regardless of this being a folktale, there is a strong suggestion here that cats were known to be able to make meaningful marks with their paws. It is significant that no other animals in German folklore were able to do this and even animals with magic powers had to become cats before they could mark. There is an example of this later in the story when the Queen, who has of course become lost in the labyrinth and had both arms bitten off in a struggle with the bear (who has changed himself into a lion), finds her daughter in bed with a dog. Before she can do anything, however, the bear once more assumes the guise of the cat and quickly writes a word on the wall that so infuriates the dog he decapitates both mother and daughter before being finally killed by the bear who in reality turns out to be the cuckolded King. (In the end, justice is done as the dog was the queen's ex-lover and the King's son by a previous marriage).

A rare case of cat painting being seen in a positive light during the Middle Ages occurs in the Book of Kells where we find an illustration of a saint with the head and paws of a cat. It seems likely that this is Santo Gato (Saint Cat), referred to by Giraldus Cambrensis in his *Topographia Hiberniae* where he records the legend of a cat who, "...had many toes and did ably assist with the work of illumination." The cat in the Book of Kells does have extra toes (polydactylism), and it is probable that this oddity in one of the monastery cats, coupled with an ability to mark, would have led to its being venerated as a messenger of God.

Below:
Santo Gato or Didymus. Detail of original, 33 x 24cm, from Book of Kells, c. 900 AD. P. 48, chapter 17, St John's Gospel (St Columkille's MS). University of Belfast. A legend recorded by Geraldus Cambrensis in 1185 tells of a many-toed cat who assisted the monks at the monastery church of Columkille in Ireland with their work in illuminating the Book of Kells. It seems natural that monks who were cloistered away illuminating manuscripts would have enjoyed the company of cats, and as artists themselves, would have been interested in a cat's ability to make marks with the paints that were available. Given the monastic setting, it would also have been natural for the monks to give these marks a religious interpretation. Another suggestion is that the monks may have thought the cat was moved to paint by the intense nature of the holy influences surrounding it, thus confirming their own purity of spirit.

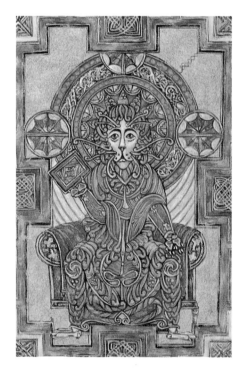

Right:
Mediaeval bestiary illustration, c.950 AD. 41 x 27cm. From a manuscript in the Bodhead Library, Oxford.

In this illustration, two cats appear like humans in an alchemist's laboratory. The caged bird and the sleeping dog, prey and enemy of the cat, are about to be transmuted into gold, represented by the rectangle in the background. Later they will be made into more moons, symbols of the cat's spiritual power. The cat standing at the easel has taken paint from the conical containers below and is probably drawing a plan of the method to be used. Such depictions of the cat involved in dangerous pastimes doubtlessly led to the expression, "curiosity killed the cat." A later illustration in the same manuscript depicts a cat holding a rat out in front of it and squeezing its back legs together in order to force blood from its mouth so it can use it as a paint brush.

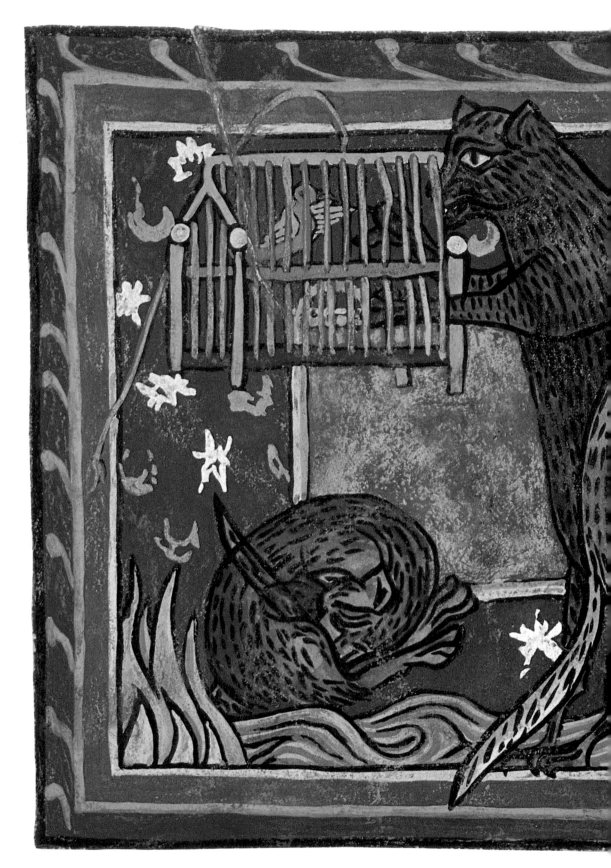

20

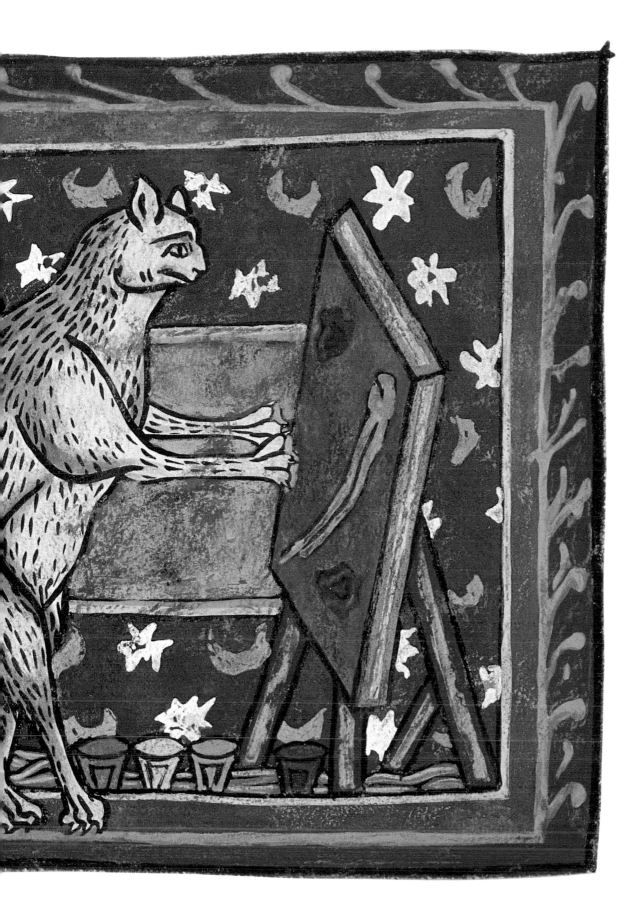

The cat ceased to be persecuted as a witch's familiar in Europe during the mid eighteenth century and while it was safe from slaughter, its marking behavior now became trivialized in accordance with its new status as a domestic pet. Dr. Johnson, a cat owner himself, is reported by Boswell as making the following scathing remark to Hester Thrale, who was bold enough to suggest some form of communication in a cat's scratch marks on a wooden door. "Show me, Madame, one word of meaning in these scratchings and I shall find five and fifty volumes in the tangled mess atop your pointy head!" A clever put-down perhaps, with its oblique reference to witchcraft, it nevertheless shows that cat-marking was observed and thought by some to be a form of communication.

By the early nineteenth century, cats were popular in the lounges of well-to-do ladies and their marking behavior was encouraged as a source of idle amusement. Bowls of flour were provided for cats to dip their paws into and "...they did then make prints upon a black velvet cushion which were read with great cleverness by Madame Sloan as to our fortunes and to the accompaniment of much mirth."[1] This frivolous pastime inspired a number of purpose-made tapestry cushions with scenes of cats painting.

[1]*Mrs. Stantiloup in* Dr. Wortle's School, *a novel by Anthony Trollope. Blackwood's Magazine, July 1880.*

Below:
Tapestry Cushion, c.1856. 36 x 46cm.
Mary Morris Collection Ascot.
Amongst the well to do in the mid 19th century, cats were encouraged to make marks with flour on velvet cushions which were then read in much the same way as teacups are today. This practice led to the making of cushions specially for the task with appropriate tapestry designs of cats painting. The following well known children's rhyme also owes its genesis to this pastime.

Pussicat, Wussicat with a white foot,
On a black cushion your spotty mark put.
One dab is a "yes" and two is a "no",
Pussycat, pussycat, give us a show.

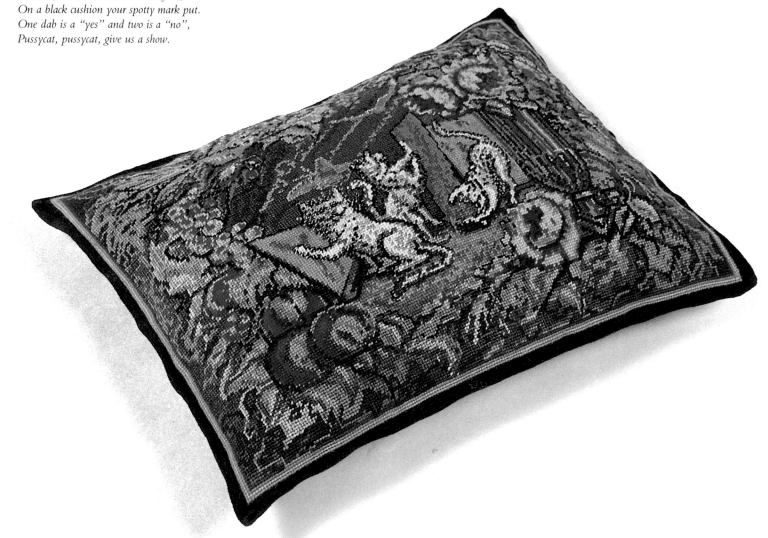

Right:
Tarot cards of The Moon and The High Priestess. c.1924.
Both these cards show the marks cats have made with their paws and attribute spiritual values to them. In The Moon card, the cat is using the ever-flowing waters of the unconscious as a medium with which to paint flaming cat's eyes to guide us on our journey to enlightenment.
The High Priestess appears in the form of a cat and her marks are given equal weight with the human signs that appear on the twin pillars of wisdom. She has curved her tail into the shape of the horn opposite, so as to present two horns, above which she sits in order to imply a dilemma.

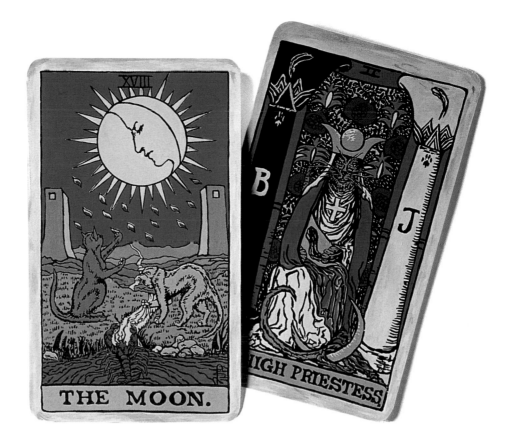

Further evidence that cat-marking behavior has been observed for many centuries can be found in several tarot card illustrations. In the tarot of The Moon, two cats are depicted scooping up the Golden Waters of the Unconscious, associated with dreams, psychic impressions, spiritual perceptions and intuitions. They are using this golden water as a medium to paint between the twin towers of enlightenment, through which we must pass if we wish to progress spiritually. They are painting flames in the shape of cat's eyes which will act as lights to guide us on the journey. Those who choose this card are assured of deep artistic qualities. In the reverse this card suggests aesthetic affectations.

The High Priestess is shown as the daughter of the moon, guarding the gateway that leads to psychic consciousness. She is often taken to be Diana who took the form of a cat, and her paw marks are given equal weight with human symbols. Her marks on the pillars of wisdom are those of the question mark, the curled-over form of the tail with a paw print representing the dot at the bottom. Her mark on the scroll suggests written knowledge. This feline priestess commands us, via the sign of the question mark, to inquire as to the meaning of the inner voice if we wish to pass through the portals of self-knowledge. Those who choose this card are likely to display great literary depth. In the reverse, this card suggests the desire to write only for power and commercial gain.

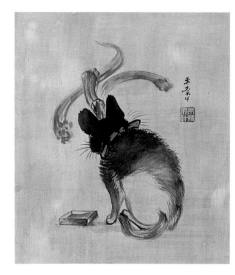

Above:
Kytan Tok, *Otakki Painting*, 1901.
Watercolor on rice paper, 18 x 26cm.
Private collection.
Otakki became famous around the turn of
the century for her paintings which
brought many customers to her owner's
store in the north of Japan. Statues of cats
painting, called Maneki neko, are still put
in shop windows throughout Japan as a
sign of good service.

Far right:
Mrs. Broadmore's Amazing Painting Cat,
c.1887. 65 x 47.5cm. Lithograph,
Museum of Animal Acts, Wisconsin.
Cat-marking behavior was trivialized in
Victorian times as this poster shows.
While Mattisa certainly painted, most of
the performance was concerned with
putting down women who might take cat
marks seriously rather than encouraging
any insight into what the cat's motivation
might be.

From the late nineteenth century, the cat had largely lost its association with the psychic and become a source of interest to breeders as a pet. Its ability to paint was now treated as a curiosity to be exploited for money rather than studied for any deeper motive. In 1893, a general store keeper in the village of Otaru in the north of Japan sold paintings done by his cat, Otakki, that were vaguely reminiscent of Japanese calligraphic characters. Because of this similarity, he was able to give them a fortune telling function and use this to attract customers to his store. Stories of Otakki's ability and the wealth she brought her owner spread quickly throughout the country and, by the turn of the century, pictures of her painting had become a symbol of good service and economic success. Even today, many shops in Japan have a statue of a cat in the window with its paw raised in the painting position in order to attract customers.

The best known painting cat in recent history was undoubtedly Mattisa, a ginger tabby who was the star attraction in Mrs. Broadmore's show at Chatsworth Gardens in the late 1880s. Mrs. Broadmore was in fact a rather portly gentleman by the name of James Blackmun who had been a strongman–clown in Barnum and Bailey's Circus. He adopted the name of Broadmore as a joke (he couldn't get more broad), and, attired as a female, did a wicked impersonation of a rather stupid upper-class matron. If the audience came expecting a serious performance as the poster (page 25) promised, they were evidently not disappointed to be treated instead to a comic act in which Mrs. Broadmore claimed that the marks made by the cat were in fact portraits of people in the audience.

Reviewing the act in 1888, Florence Fenwick-Miller wrote, "After regaling the audience for fully ten minutes on the creativity of cats, Mattisa, wearing a white painter's smock, is carried on stage and placed atop a high table alongside her paints and tiny easel. All the while stroking the cat, Mrs. Broadmore enquires as to which member of the audience the cat intends to paint. In order to receive the answer she then inclines her head towards Matissa's face and at once the cat places its front paws on her shoulder and appears to whisper in her ear. 'Oh, the lady in the red hat just there! Yes, she does have an interesting face!' exclaims our hostess in her peculiarly deep voice. 'Well, you will be needing some red paint then, will you not?' The moment the paint is placed in front of her, the cat applies her paw to it and at once stands up on its hind legs and makes several marks on the canvas. Much to the amusement of the assembled throng, Mrs. Broadmore now considers the work from several angles, all the while peering intently at the hapless woman with the red hat to check its accuracy. 'I do not think you have quite captured the nose,' she intones finally. Asked for their opinion, the audience inevitably side with the cat and at the end of the performance more than a few show their support for the feline arts and buy these 'pawtraits' for a florin or even more."[1]

[1]*The Ladies Column, London Illustrated News, July 14th 1888.*

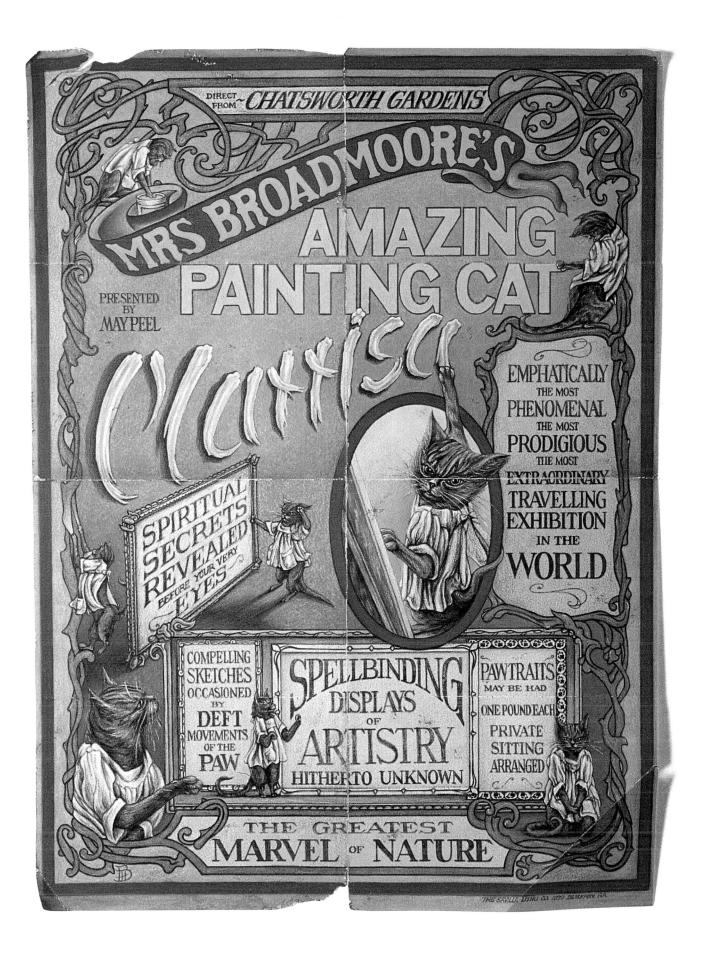

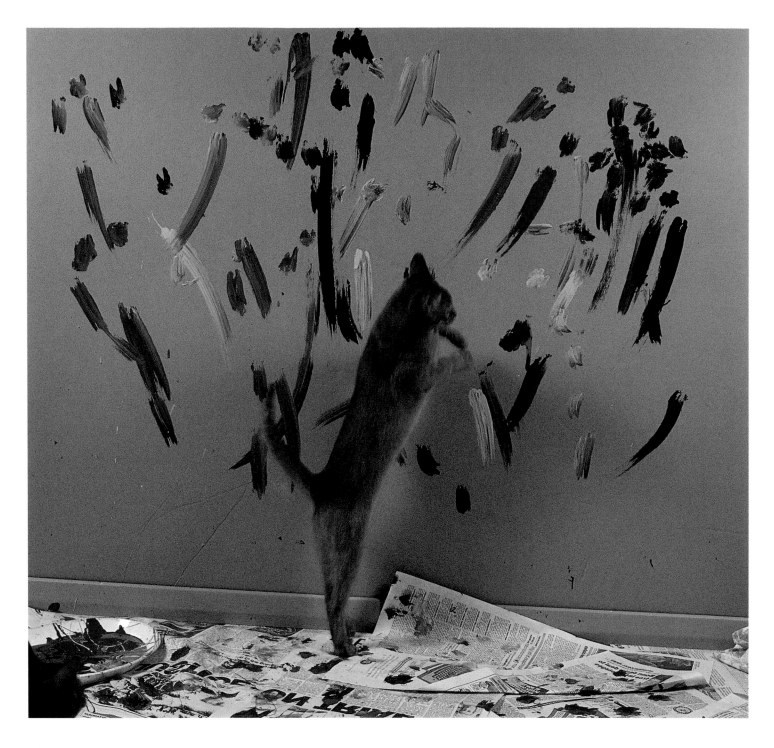

Above:
Bonnie, painting a wall. Boston, 1989.
Because of the abandoned manner in
which some cats paint, biologists have
branded their work as no more than an
"obsessive-compulsive play activity
which results in randomized marks of
no meaning whatever."

Chapter

2 | Theories of Feline Marking Behavior

Biologists have been reluctant in the past to concede that cat painting could be aesthetically motivated, preferring instead to explain it either as a form of instinctive territorial marking behavior, or as the playful release of nervous energy. Those holding this latter view cite the "...abandoned manner in which some cats pounce at the canvas allowing paint to fly in all directions..." as evidence of what is, "...no more than obsessive-compulsive play activity resulting in randomized marks of no meaning whatever."[1] However, to be consistent in this line of reasoning would require us to reject a good deal of human Action Painting as well. The work of Jackson Pollock, Willem de Kooning and many other abstract expressionists, could be dismissed on similar grounds.

A more substantial case is made by those biologists who suggest that cat-marking behavior is territorially based. They point out that domestic cats rely not just on the scent of their feces to mark their territory but also physically mark its position with carefully 'drawn' lines radiating out from it. We've all seen how cats do this; carefully scraping long grooves in the

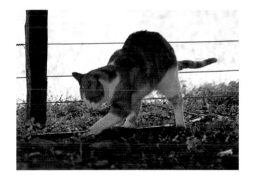 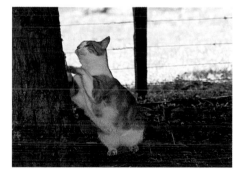 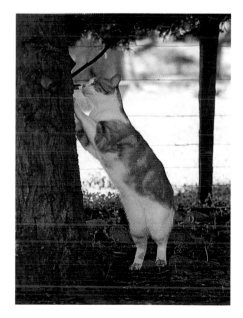

Above:
Cats not only rely on the scent of their feces to demarcate their territory but also physically mark its position by carefully 'drawing' lines that point towards it like a large arrowhead. These are clearly visible to other cats long after the scent has faded.

Above & right:
The cat uses the soil that remains on its paw to make even more visible territorial marks higher up on the tree trunk. This type of instinctive vertical marking behavior is thought to have laid the biological foundations for cat painting.

[1] Camlet, M. *The Mentality of Cats. XVth International Congress of Art and Nature, Oslo. 1988.*

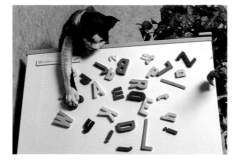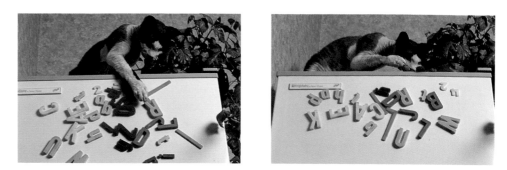

earth or litter that point directly to the feces like a broad arrowhead. This acts as a territorial marker which can be clearly seen by other cats long after the scent of the feces has faded. To further extend this demarcation some cats will use the earth that remains on their paws to make even more visible marks higher up on a nearby vertical surface such as a tree trunk or wall.

Biologists argue that cat painting is merely an extension of this instinctive vertical marking activity. Asked to explain the motivation behind it, they claim cats are stimulated to mark by the odor of ammonia salts used as a drying agent in acrylic paints (cats will not paint with oils) which smells remarkably similar to their urine. However while it is reasonable to assume that the cat's instinctive need to mark its territory may have laid the foundations for its painting behavior, the major reason cats paint today appears to be largely aesthetic.

We shall never know the origin of the primal feline aesthetic gesture but it seems that wherever domestic cats are well looked after and have little need to define their territories, their marking behavior tends, in some rare instances, to become what Desmond Morris (writing about chimpanzees), calls a Self-Rewarding Activity. These activities, "...unlike most patterns of animal behavior, are performed for their own sake rather than to attain some basic biological goal. They normally occur in animals which have their survival problems under control and have a surplus of nervous energy which seems to require an outlet."[1]

But cat painting appears to be motivated by more than the need to release energy, and, far from being the result of randomized pawings, is in fact the product of an ability to recognize and manipulate form and structure. For example, we now know that some domestic cats are able not only to distinguish between colors but seem to 'enjoy' making spatial adjustments to objects of different colors. In 1992, the *Guardian Weekly* ran a story on a ginger tom in Seattle able to sort jelly beans according to color,[2] and in San Francisco a female Rex will spend up to two hours carefully arranging magnetic letters on a refrigerator into groups of the same color. In both cases, the cats become totally absorbed in the task which seems to have no purpose other than the aesthetic pleasure of color grouping.

[1] Morris, Desmond. The Biology of Art. *London, Methuen, 1962.*
[2] Whitlock, Ralph. The Cat That Got The Beans. *Guardian Weekly, July 19, 1992.*

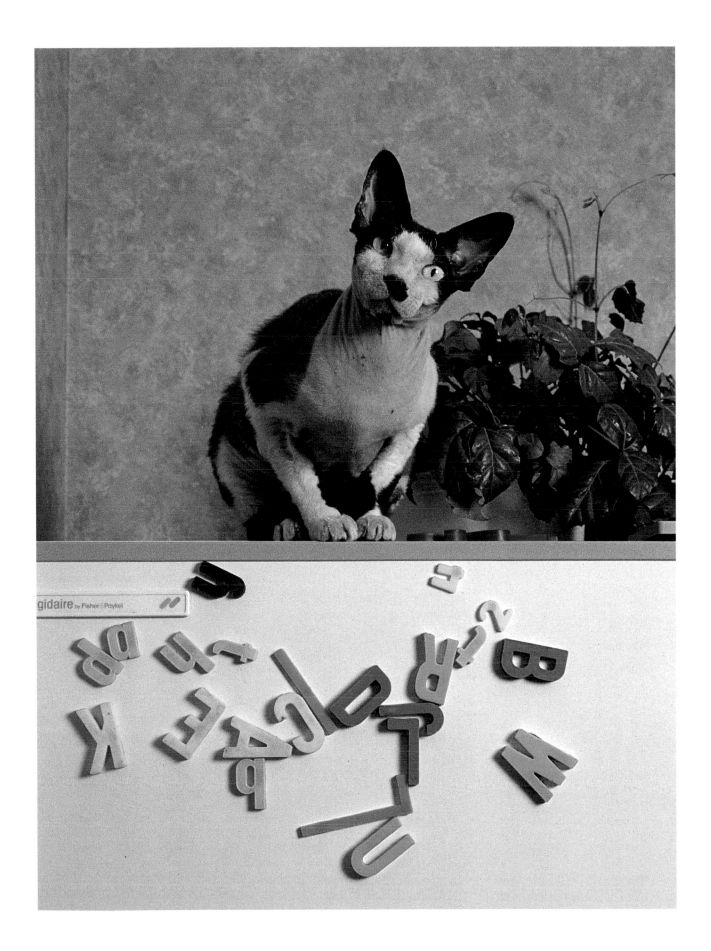

Above:
Studies show that cats spend about 3% of their play-hunting time lying on their backs looking at things upside down. A recent theory contends that this may be partly why cats invert objects when they represent them in their paintings - a practice known as "Invertism" which was not discovered until recently because cat representations are very basic and not as easy to recognize when inverted as more complex motifs are.

The fact that some cats are able to make representational marks was not discovered until quite recently, and then almost by chance. In 1982, Arthur C. Mann began an investigation into the prolific marking behavior of a ginger tom named Orangello who lived in Sussex (see foreword). Towards the end of his study, he happened to look at some of the paintings upside down and noticed that a few of the motifs bore a more than slight resemblance to objects in the house that Orangello saw every day. Further study in 1983 of a female tabby convinced him that some cats are able to make crude representations of objects but, for some inexplicable reason, always paint them upside down. Dr. Mann died before his research was complete and, even though he never came up with a satisfactory explanation for the phenomenon, he did coin the term "invertism" to describe it.

Later investigative studies by Dr. Peter Hansard working with Ching Ching in Cambridge (1987), and Dr. Delia Bird with Eliot in Oxford (1990), confirmed Mann's findings, though their explanatory material differs somewhat. Hansard favors a functional approach which takes account of the fact that cats spend about 3% of their play-hunting time lying on their backs looking at things upside down. By measuring their pupil dilation, he was able to show that cats experience a stronger state of emotional arousal at these times and suggests this occurs because "...the cat perceives the inverted object as something unfamiliar invading its territory and later paints and marks it in order to disarm it." The cat does this he says by "...first representing the object, or an aspect of it, in its unfamiliar inverted form and then marks it with the usual territorial arrowhead shape as it does when marking its own feces. By doing this, the cat claims the offending object as its own and thereby renders it safe by asserting its control over it."[1]

Bird, on the other hand, feels that invertism is aesthetically motivated. Her study found that objects which were subject to inverted observation by the cat were no more likely to appear inverted in its later paintings than other objects which it had observed the right way up. Furthermore, she noted that many of the marks Hansard would consider territorial, could just as easily be interpreted as a representational part of the painted object (see illustration, page 31). Bird concludes that cats may invert when making representational marks, "...in order to explore form and structure from a fresh perspective by emphasizing abstract qualities."[2]

Both points of view must remain open to conjecture, but it is interesting to note, in Bird's favor, that the well-known German neo-expressionist, Georg Baselitz (b.1938), also paints his motifs upside down in order to counteract conventional modes of observation.

While the establishment of a coherent theory of feline marking behavior is still some way off, it has been brought a good deal closer by the work of Dr. Peter Williams who heads the Department of Applied

[1]Hansard, P. Functional Invertism in Feline Territorial Demarcation Activity. *Jl. of Biometrics, Vol. 1, 1989.*
[2]Bird, D. Eliot and the Aesthetics of Feline Invertism. *Journal of Non Primate Art, Vol. IV, 1992.*

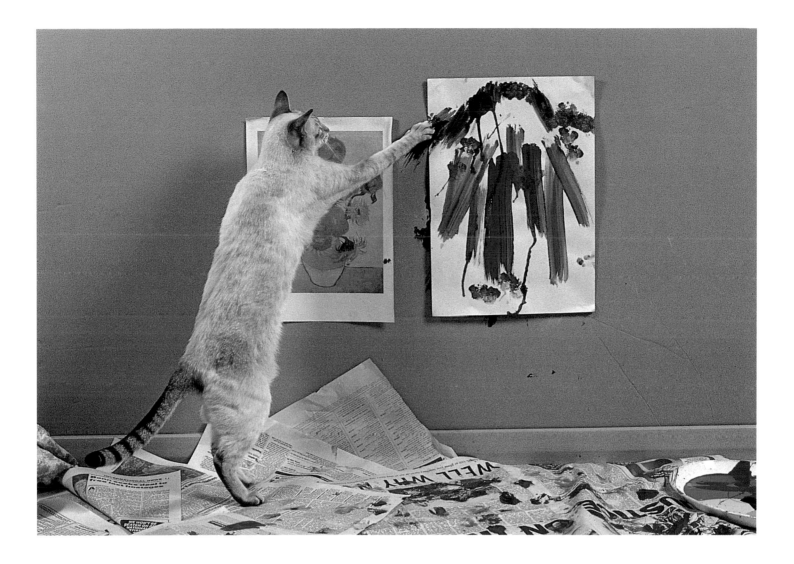

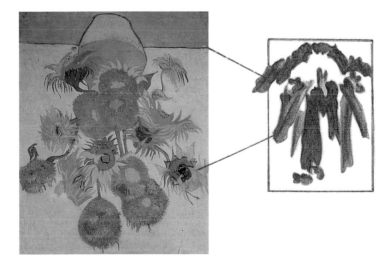

Above & left:
Buster's representation of Van Gogh's *Sunflowers* is a good example of invertism. From a purely visual perspective, the brown mark at the top of the work clearly represents the dark line which defines the edge of the table and the bottom of the vase, as shown in the photograph (left), while the blue marks represent the flowers.

However, biologists interpret these blue marks as territorial and similar in function to the arrowhead paw marks cats make to demarcate their feces. In the painting these marks signify ownership of the inverted object and are thought to have the function of rendering its unfamiliarity 'safe.'

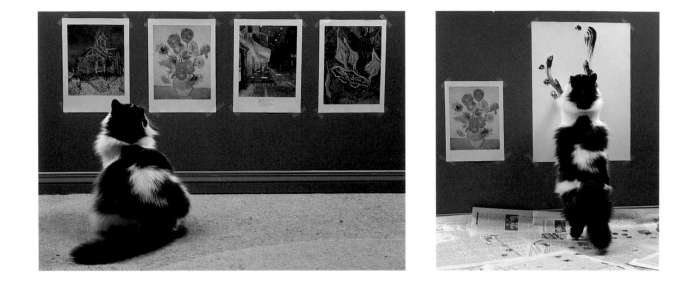

Above:
Cats show a distinct preference for the paintings of Van Gogh which is thought to be due to their being able to relate to the swirling fur-like nature of his brush strokes.

Above right:
It appears that cats may be stimulated to paint by localized low energy force fields known as Points of Harmonic Resonance. Despite the close proximity to Van Gogh's *Sunflowers*, this cat, a male Harlequin, was probably far more 'inspired' by a resonant vibration than the human artwork, to which its painting bears little relation.

Aesthetics at Rudkin College in Dallas, Texas. Evidence for an aesthetic motivation was predicated by a series of experiments he ran in 1987 to determine the degree to which domestic cats may display partiality for different works of human art. Because cats show a distinct preference for the works of Van Gogh, usually attributed to their being able to relate to the swirling fur-like nature of the brush strokes, Williams chose four posters of this artist's work and set them low on the wall in the cats' living space. By measuring the amount of time each cat spent looking at the different pictures over a six-week period, he hoped to be able to determine any preferences. The results were dramatic. All three cats, two female Siamese and a male Harlequin, spent 83.2% of their upright sitting time gazing at Van Gogh's *Sunflowers*. In order to check his results, Williams swapped the pictures around, only to discover that now the cats spent 81% of their time in front of *Café at Night!* A third swap six weeks later and *The Church at Auvers* became the favorite. What was going on?

"In experimental situations," Williams noted later, "you can become so obsessed with your hypothesis that the most obvious explanations completely escape you. I should have realized much earlier that neither the pictures nor their positions had anything to do with the cats' behavior. The fact was, that for some reason, they simply preferred to sit in a very specific area of the room which just happened to be right in front of one of our picture positions." It was also the way they appeared to be attending to a particular painting that made him think they were delighting in it. "They would sit there with their eyes half closed, purring and sometimes rocking slightly, though not asleep, as if the image before them was one of the most beautiful things in the whole world, as indeed Van Gogh's paintings are to us."[1]

A study by one of Williams' students who used tiny radio transmitters to track the daily movements of ten cats, found that four of them had

[1]*Private interview recorded by the author. Dallas, 1988.*

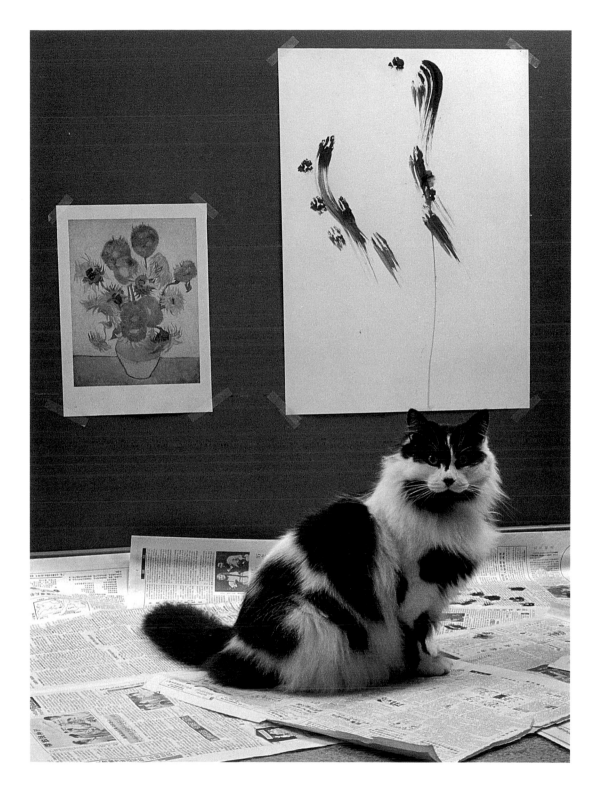

Above:
Maxwell, *Blossoms Blue*, 1991. Dye on
yellow card, 48 x 72cm. It has been sug-
gested that this work may have been
inspired by Van Gogh's *Irises*, a print of
which the owner has hanging above her
bed, where the cat sleeps every night.

Above:
The typical pose of a cat when sitting at a
Point of Harmonic Resonance. The eyes
are slightly closed and the cat will gener-
ally purr and may rock gently back and
forth. Almost all cats that paint spend at
least ten minutes in resonance prior to
commencing a work, which suggests they
derive some inspirational power from
these invisible low frequency force fields.

preferred sitting areas that seemed to have little to do with warmth, scent or territorial observation. The cats would simply stop and sit in the middle of nowhere and begin purring as if they'd just been struck by the most delightful idea. The fascinating thing was, that at these times and only these times, small amounts of low frequency electrical interference were picked up by the transmitters the cats were fitted with.

It seems that some cats are able to experience a kind of localized force field or meridian in certain areas from which they derive a benefit. Peter Williams calls these areas Points of Harmonic Resonance and claims they may play an important part in motivating cat painting. It certainly appears that way with now four independent studies showing, that of the few cats who paint, almost all of them spend a large amount of time sitting in resonance immediately prior to painting.

Just why this should be so is still unknown, though it does appear that the cat derives some power from it. Certainly there are cats, often young and inexperienced ones, who will walk into one of these areas and become suddenly overloaded with a charge that's strong enough to make them dash madly all over the place. It may be that purring is a way of channeling the energy, or it could be a way for the cat to mimic the harmonic point's vibration and receive a kind of substitute benefit. At this stage it's all open to conjecture, but what is most exciting is that harmonic resonance could well be the vital clue in helping to explain what triggers the feline aesthetic response. Is it what inspires cats to paint, or do they paint its power? More importantly perhaps, could it be the influence of some intersection of lay lines, or something like this that causes us to see something in a certain way and make us want to paint it? It seems there may be much we can learn about the art of human beings by studying the art of the cat.

Right:
The fact that cats spend more time in our company than they do with their own species, suggests that there is something in their nature which echoes the higher levels of the human psyche.

Chapter

3 | Twelve Major Artists

Because this book is designed to function both as a work of reference and as an introduction to contemporary cat painting, it has been necessary to select only those artists who, in the author's opinion, best represent the major movements current at this time. Naturally this has necessitated some omissions and readers may be surprised to find that several cats whose work has risen to prominence of late are not included. This is usually because their notoriety is based on some particularly unusual technique or performance ability and is not representative of a movement or art-style as a whole. Also omitted is a quite recent 'trend' known variously as Fat Cat Chat, Claw Whore, or Neo-Felinistine. Time will tell if this peculiarly violent and destructive form of painting, popularized by the British and American Shorthairs, develops an integrity and viewpoint that would justify its inclusion in a future survey of this kind.

The actual number of known cat artists is still very small, with most being found in or near major cities where large populations can provide sufficient numbers to enable the formation of Cat Art Societies. It seems likely as interest in cat painting grows, especially in the newly 'awakened' areas of Eastern Europe, Russia and China, that many more feline artists will emerge with entirely new styles and messages. For this reason we cannot claim that the works included in this selection are representative of cat painting internationally. Rather, they show the important work of a small minority who are currently exhibiting and having their work sold in the West.

Almost all the works in this chapter have been given a title either by the cat's owner or its curator. The reason for this is straightforward. Just as surrounding a painting with an expensive frame and hanging it in a gallery places a value on it, so too, naming a work confirms artistic intent and allows it to be legitimated and taken seriously. Certainly, by titling a cat's painting, we provide a context within which judgements of aesthetic worth are made. A title such as *Fluff and Kittens* for example, is likely to suggest a different level of worth compared to *Maternal Arrangements* or *Coital Consequences # 4*. Be that as it may, titles nevertheless provide a clue, a starting point, no matter how arbitrary or contextually biased, from which to begin our journey of discovery. Without them, we run the risk of dismissing cat painting as being no more relevant than the mindless territorial daubing of the graffitist.

WONG WONG & LU LU

Duo Painters

Seeing Wong Wong and Lu Lu working together now, it is difficult to believe that their initial encounter was so filled with mutual hostility. Lu Lu (Luigi Vibratini Paletti), a Seal Lynx, had already established himself as a major Italian cat painter when Wong Wong, the lithe brown Havana eight years his junior, took up residence in an adjoining villa. Their first meeting on Lu Lu's Sansovino property near Bologna was witnessed by his owner, Sofia di Baci. Lu Lu was completely engrossed in painting the very large *Mural in White* (inspired by a distressing incident involving a

Above:
Using his higher reach, Lu Lu completes the central motif of the *Wonglu* triptych by adding a few subtle 'off-canvas' smears. These action lines give the white form an immediate sense of movement which suggests a dynamic relationship.

Right:
Lu Lu signals his completion of the triptych by licking Wong Wong all round her face. Three days later, Wong Wong gave her final approval by making two black paw marks under the central motif, (page 39).

row of milk bottles and the domino effect), when Wong Wong sauntered over from the shrubbery from where she'd been watching and calmly added a few graceful, paintless strokes of her own, just as if she'd been doing it all her life. The resulting confrontation left Wong Wong very much the loser (and very much the whiter). But as the weeks went by, her great interest, and persistent attempts to help, obviously impressed Lu Lu and led to her eventual acceptance as his painting partner.

Their initial collaborative works, *Breakfast for Dogs* and *Purr Balls,* 1990, lacked any clear direction. At over five meters long (down both sides of a Fiat Tempra station wagon), these murals were perhaps too ambitious. They lacked spontaneity, and Lu Lu's deft paw strokes were often confused by Wong Wong's exuberant introduction of irrelevant and poorly inverted material from unrelated experiences. While this added to the immediate lightness of the works, it tended to hinder their overall meaning. A far cry from their more recent work, *Wonglu,* 1992, the name signifying a deeper, more profound relationship and a unity of aesthetic purpose.

During the painting of this triptych, Wong Wong repeatedly stopped and rubbed up against Lu Lu, something her owner feels sure she did not only to gain guidance from the older painter, but also to share the works' progress with him on some kind of psychic level. This is borne out in her treatment of the large white form, which, according to critic Donna Malane, "... completely dominates the work and suggests a strong duality of positive emotion; 'giving,' shown at the lower open end of the white motif, coupled with a drawing towards 'accepting' in the upper moiety. The heavy, somewhat negative verticals in the left panel combine to echo this

curl but the circle is tighter, less open and more selfish—the negative side of a working relationship?" Streaks of white were added to the uppermost tip of the dominant form by Lu Lu who has the higher reach. These "... action lines, give a definite sense of movement and imply an ongoing relationship." Lu Lu was content to sit back and wait for Wong Wong to complete two panels in her usual flamboyant manner before moving to add numerous bright little highly textured dabs of his own. These, according to Malane, "...have a diffusing effect, absorbing the dissonance set up by the conflicting messages of the first two panels."[1] An interpretation which helps to explain Wong Wong's need for a long comforting licking from Lu Lu on completion of the work.

[1]Malane, D. Exhibition Catalog, *New York. (While conceding that the central white motif does have strong emotive qualities, Ian Wordly, writing in the same publication, argues that it is more likely to be Tail Symbolist and therefore suggestive of the mercurial nature of their relationship).*

Below:
Wong Wong and Lu Lu pose in front of their parts of the *Wonglu* triptych. This work sold for $19,000 at auction in 1993, one the highest prices ever paid for a work of cat art. (Note Wong Wong's final two black paw marks in the lower left quadrant, acknowledging that the work is the result of collaborative effort).

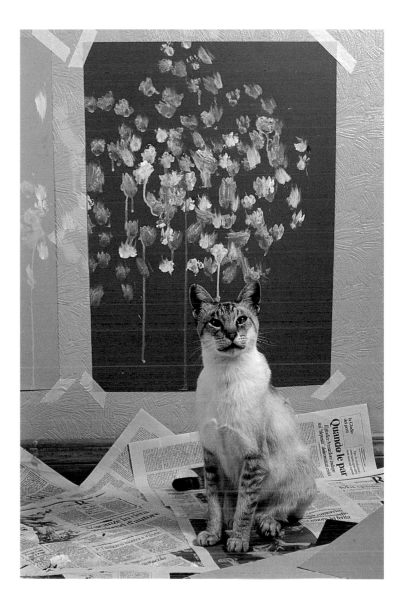

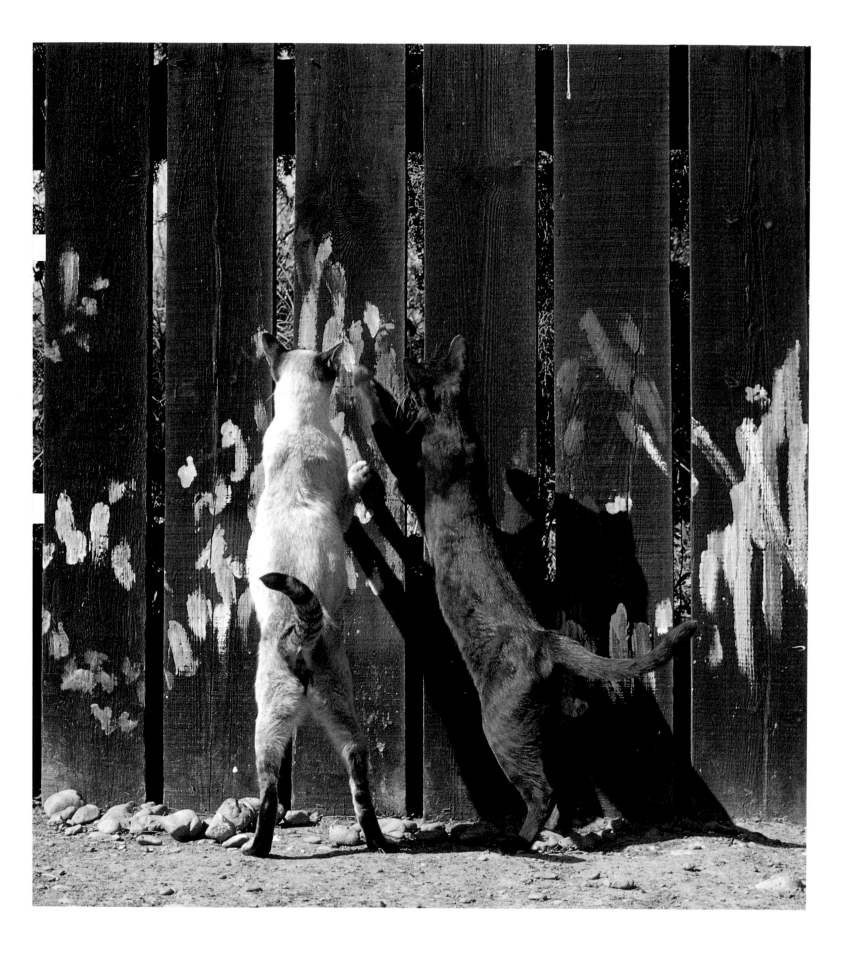

In *Journey by See,* 1992, painted over five days on a brown fence, their two styles find a satisfying confluence. "The finely ridged, even grain of the painted wood reflects the light in web-thin strips that create a microcosm of silken threads, immediately recognizable as the sheen of Wong Wong's rich brown fur. The gaps (small), between the palings (broad), suggest both gaps in experience and collaboration. But these small voids are now triumphantly bridged by joyous shapes and colors that flow from board to board in a continuous reuniting dance of harmonic bliss. The once broken is made whole again."[1]

Much of their current work contains this simultaneity of romance and innovation. Here it awakens feelings and associations of renewal and completion with its free and open leaps of color across the fence. While in their latest work, *Galloping,* the same blend of energy and lyricism combines to create a work reminiscent of Kandinsky's *Romantic Landscape,* where cats ride horses in the snow.

Over the last few years, Wong Wong and Lu Lu have developed a close association with two horses. Alessandro, a twelve-year-old dark brown gelding, and Lolita, a four-year-old light grey mare. The association is at once symbiotic and aesthetic. On cold mornings, the cats will venture out across the fields and spring up onto the generous rumps of the quietly grazing horses. There they perch, receiving and imparting warmth. On balmy afternoons they may take long, slow meandering wanders over the rolling hills where, high above the ground, they can survey the land and discover new points of resonance. Each cat 'owns' a horse, and each is tonally attuned. Wong Wong to Alessandro, Lu Lu to Lolita, brown with brown, cream with cream, male with female, young with old.

But all is not harmonious. There is a subtle power play here. To ride the high horse, to maintain the equilibrium of feline dignity and independence, the cat must remain poised. The horse also has its pride to maintain. It chooses who will sit on its back and who will not. Both cat and horse have positions to defend. The horse can remove the cat from its rump (the most comfortable, least slippery spot for the cat) with one flick of its tail. But if the cat is not ready to leave, if taken by surprise and unable to remain poised, its claws will instinctively bite in. To avoid this discomfort, the horse must warn the cat, and that removes its power of surprise—its ultimate control. The interplay is delicate, the relationship both delightful and unsettling. The resulting painting is acute, and at times profound.

Galloping, 1993, painted on a green corrugated iron fence, is such a work. "The evenly rippled iron provides its own topography, imbuing the painting with an immediate sense of place. The undulating corrugations arc at once suggestive of rolling hills—brightly lit tops and soft shallow valleys. The very evenness of the iron's form also provides a rhythm—the

[1]*Hamilton, L. Italian Duo Painting 1990 -93. Journal of Applied Aesthetics, Vol. IV, 1993.*

Following page:
In the summer Wong Wong and Lu Lu sometimes spend several hours a day on the back of their horses, Alessandro and Lolita. This is one of the few opportunities the cats have to move about several meters off the ground where resonances are more even and less prone to the harmonic surges encountered at ground level. For this reason, painting often follows these rides.

Left:
Wong Wong and Lu Lu working on *Journey by See,* 1992. Scented acrylic on stained wood. 974 x 87cm. Private collection, Bologna.

Below:
A preliminary sketch or dry-marking of *Galloping* made by Lu Lu three days before they commenced working on the mural. This alerted the cats' owners to the fact that they wanted to paint and allowed them to get the paints on site in time.

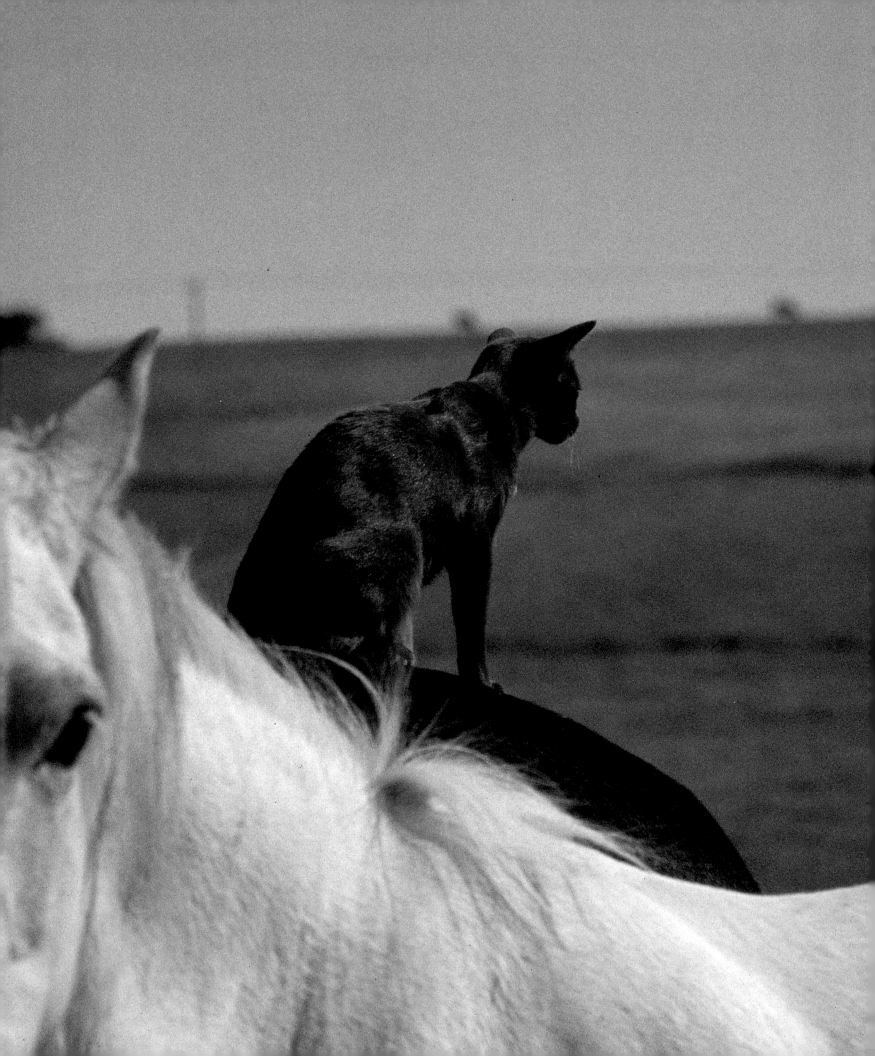

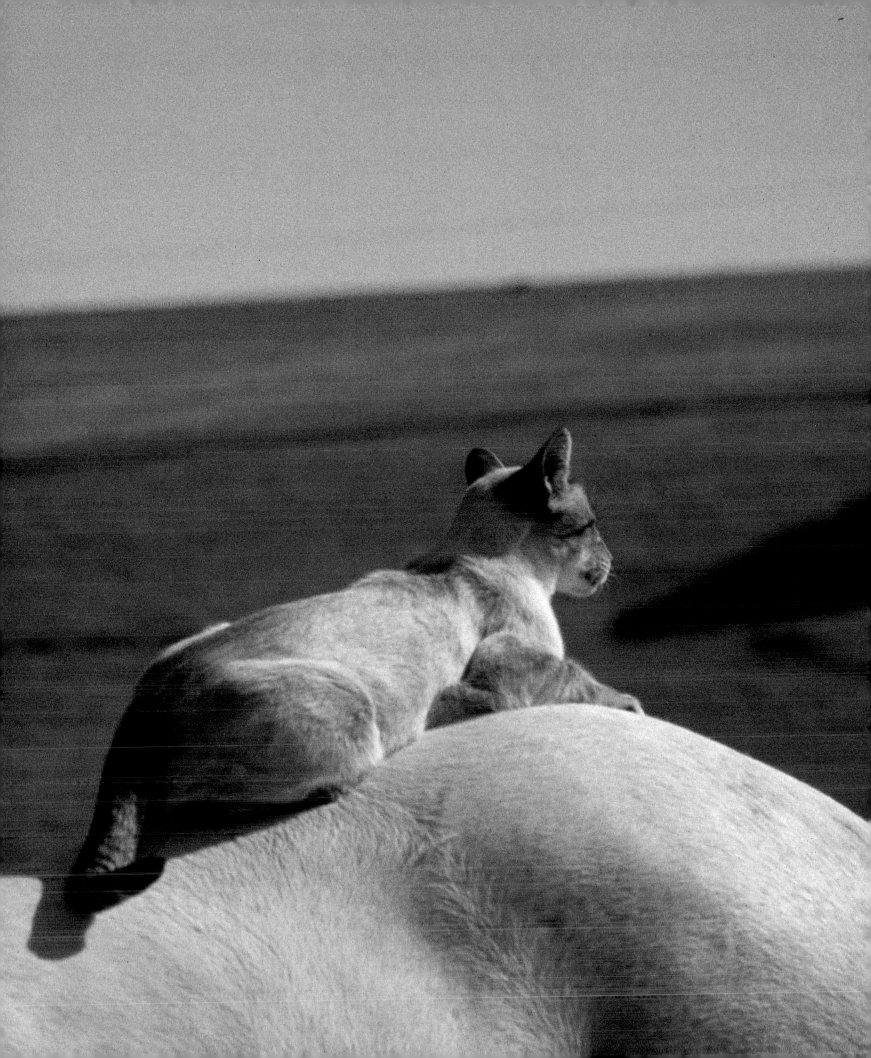

Left:

Galloping, detail, 1993. Scented acrylic on corrugated iron. 487 x 92cm.
Correa-Hunt Collection, Madrid.
White and black arched forms appear to gallop together over the regular green hill-like undulations of the corrugated iron. Lu Lu's delicate bursts of red and yellow overlay, complement (and correct?) Wong Wong's more gestural, less subtle treatment of the major forms, imbuing them with a sense of delight and movement. The crude starkness of the white figure has been given depth by overlays of gray which both soften and imply complexity.

Below left:

Interpretive Diagram, by Dr. L.P. Ashmead, for *Jl. of Applied Aesthetics,* Vol. IV, 1993.

1 & 4: Riding forms.
2: Bucking form.
3: Grazing form.
5: Butterfly (see detail, illus. opp).
6: Rearing form.
7, 8 & 10: Subsidiary shadow forms.
9: Leaping form.
11: Limb.
12: Signatory mark. (Wong Wong).

Ashmead's interpretation has been criticized by V. Hudson in the *Journal of Feline Art,* Vol. V, 1994, as being too contextually driven. She writes, "...while his interpretation of the work in the equine context is compelling, it suffers by being overly definitive. An equally convincing, though very different rationale, might also be found within a bovine context, for example, or perhaps vulpine, or cervine, or possibly porcupine, and even, might I suggest, Lichtenstein."

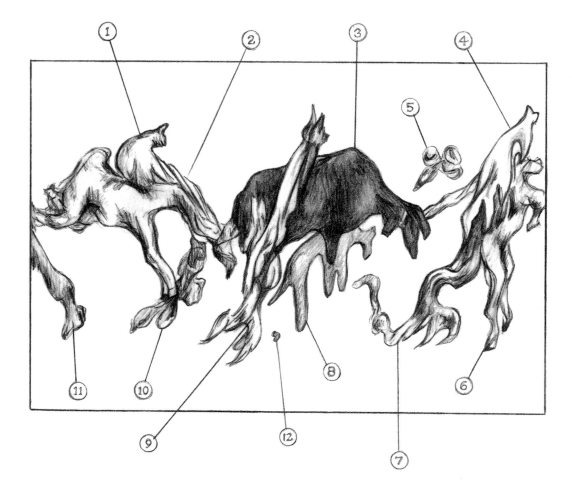

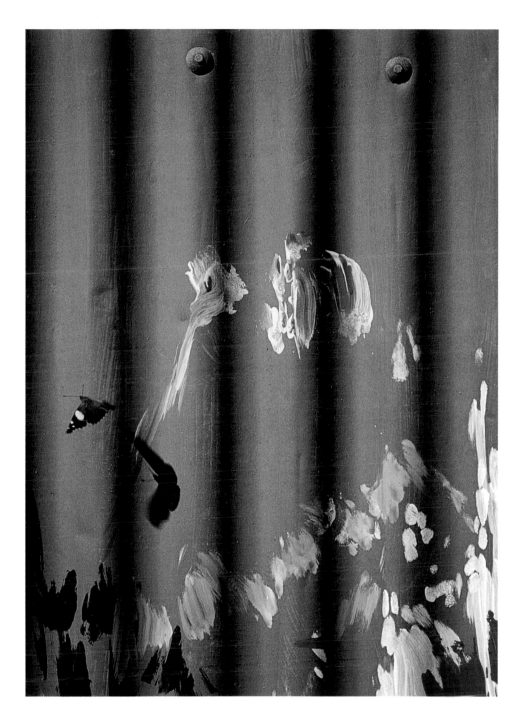

Left:
A touch of the old master. Lu Lu captures the essence of a butterfly in flight with just a few deft flicks of his paw. Later the butterfly is drawn to the likeness of itself and flutters around it for some time.

easy regular beat of horses galloping over the hills. Further, the deep shadows cast by each of the steel channels lend a definite sense of well-defined muscularity—powerful, boldly shaded legs that plunge directly into the ground—anchoring, stabilizing. It is on to this richly ambiguous surface that the paint is generously applied in long even strokes, at once reflecting and altering its inherent rhythms, capturing a sense of movement, a surging forward, cats and horses together in a joyously energized cavorting, that sweeps us up and takes us along for the ride."[1]

[2]*Downes, David. Exhibition catalog, 1993. The complete text of Downes' critique was first published in the catalog of La Expoizione dell'Arte Felino, Milan, 1993. It further explores the relevance of* Galloping *in establishing a feline equine dynamic in the context of Trans-Expressionism.*

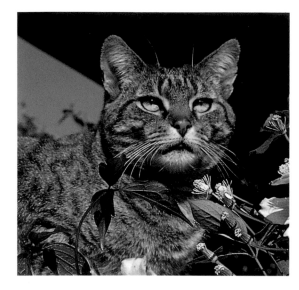

Above:
Pepper, (1979-1993). At home in
Manhattan, 1992.

PEPPER
Portrait Painter

Pepper was born on a small farm near West Town, N.Y., in the fall of
1979. Being the only male in a litter of six undoubtedly precipitated a pre-
mature sense of his own uniqueness, and that, coupled with an umbilical
hernia at birth which required constant attention, set him apart from the
rest. As early as five weeks old he showed a tendency to be aloof, spending
long periods alone gazing at his reflection in the window and, more often
than not, content to sit back and observe rather than join in with his sisters'
play activities. It is not known who his father was but his mother, while dis-
playing no artistic ability herself, was nevertheless a very conscientious
marker of the litter tray and it seems likely that Pepper's considered style was

Right:
Pepper will spend up to two hours care-
fully examining himself in a mirror before
commencing a self-portrait.

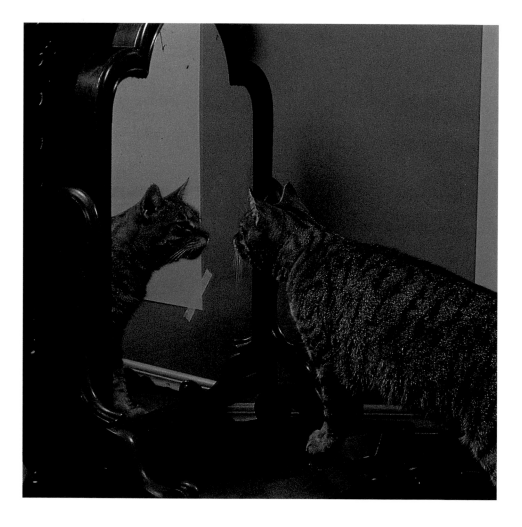

inherited from her. But it was the move to the Bacarella's spacious down-town Manhattan apartment with its large windows and broad sills that fostered a more profound fascination with his own reflected form.

His first work, with moisturizing cream on a dressing table mirror, was completed in 1981 and, while it lacked any clear form, this may have been because the smears were integral to the painter's own mirror image, without which they would make little sense. Later experimental work with facial powders and rouge, combined with some lotions, convinced his owner to supply him with the appropriate acrylics and during the next ten years, until his retirement in 1991, he painted over two hundred portraits.

Almost all his work involved self-portraiture and he would typically spend up to two hours carefully examining aspects of himself in a mirror before commencing. He then worked slowly, his painting seeming to inspire a considered awe as if he were overpowered by the enormity of each mark he made. Completion was inevitably prolonged, always requiring a final little dab here or there, several days after the main work was complete.

It was not until 1987 that Pepper showed any interest in painting Venus,

Below:
Pepper painting *Reflections # 54*, 1988. Acrylic on card, 72 x 48cm. Private collection.

"The relationship of self to a wider con-text is the antithesis of Pepper's works in self image which are iconographically firmly in the mould of egoistic self-por-traiture. What is immediately engaging is the aspect of self image as represented by this detail of his tabby markings, not as they relate to the labyrinth of wider fur patterns but set apart, in clinical isolation where examination can be de-contextualized and deeply revealing."
Pott. T. Exhibition catalog, N.Y. 1990.

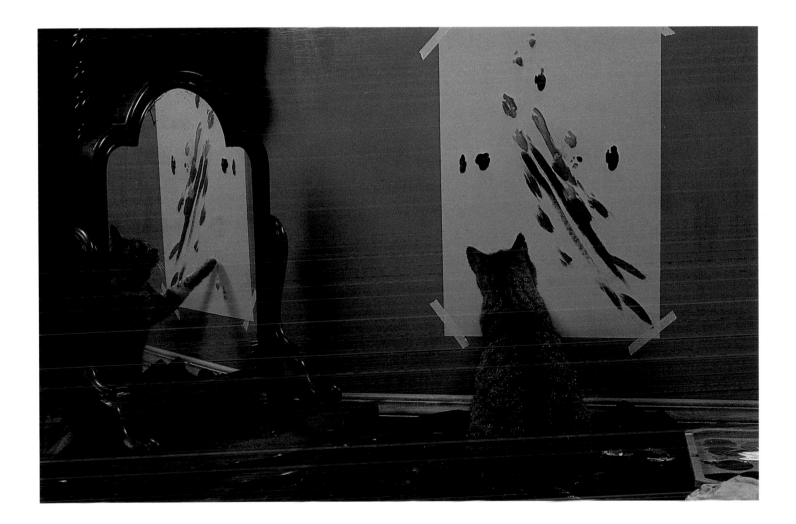

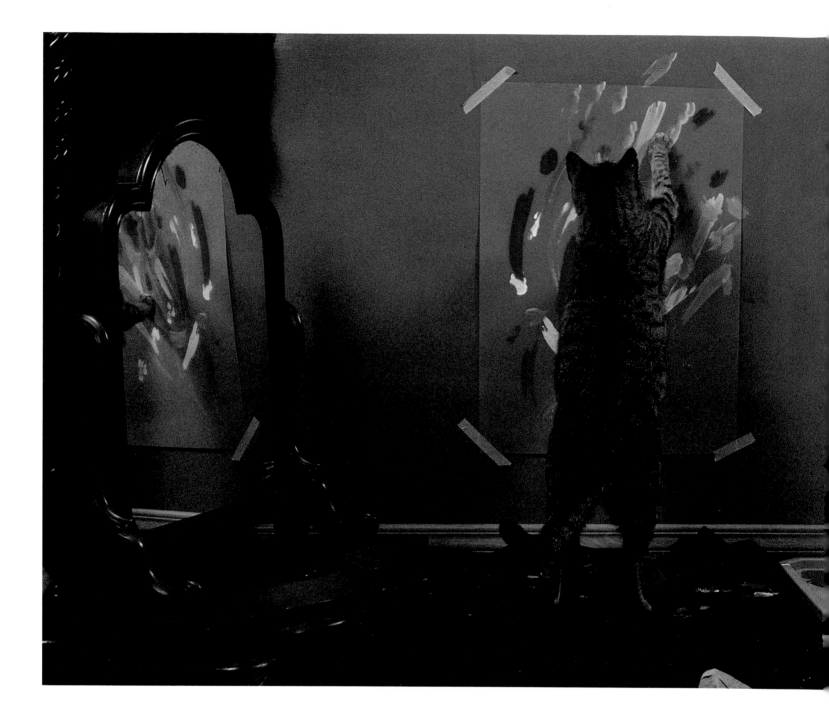

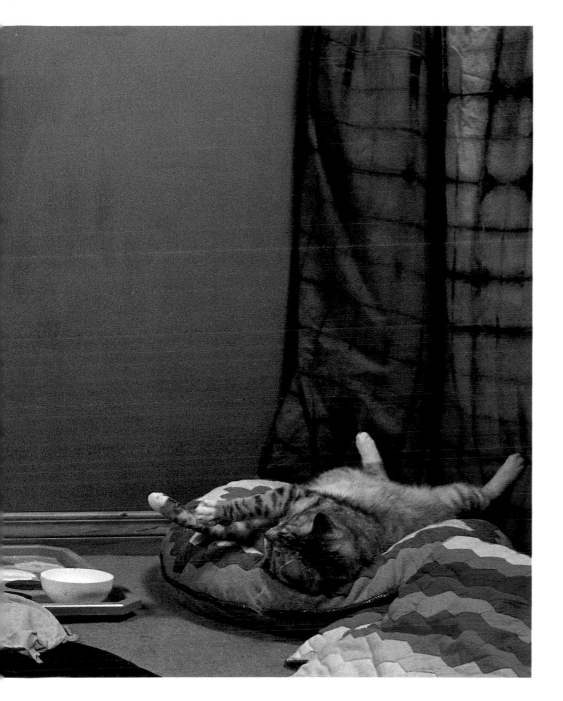

Pepper would often fight with his models
during their painting sessions which his
owner once explained as being because
"...he just loses concentration and takes it
out on them." A greater insight into this
behavior is given by Dr. David Reynolds
writing in the *Bloomsbury Book of Art*
(1992). "The relationship between artist
and model is complex. While Pepper uses
his model's provocative pose to explore
his own special reaction to it (and so gain
a greater understanding of a special part of
himself), he must also interact with her
whilst painting in order to ensure she
maintains the correct pose. This immedi-
ately exposes him to an external interac-
tion which in turn compromises the
purity of the internal dialogue he is
attempting to comprehend. The resulting
internalized polarity may explain the
incidence of externalized physical conflict
that often occurs during these painting
sessions."

the Silver Tabby with whom he shared his apartment; and then it was with
an impulsive enthusiasm as if he'd never seen her before. He would sit close
to her for hours and purr loudly until she finally adopted the exposed
supine positions he found so stimulating. Once she was suitably splayed,
Pepper would immediately begin to paint. Now there was no pausing—his
strokes were quick and vigorous as if speed were essential to capture the
nuance of the moment (which in many cases it was, as Venus often tended
to lose concentration and fall asleep in the more exacting positions). The

resulting works are lyrical, every aspect of them exhibiting the undiluted essence of quadruped exposure. As Lesley Hertzog wrote on the occasion of Pepper's first one cat-show in New York in 1988, "...these works [the Venus Series] flicker between abstraction touched by the stability of the feline form and the feline form spiritualized by the undecidability of abstraction." He never reached these heights again. The onset of Venus's arthritis in the winter of 1991 distorted her lovely limbs and robbed his art of the stimulation it had come to rely on. After that, Pepper ceased painting altogether.

Right:
Exposure # 14, 1988, Acrylic on card. 72 x 48cm. Private collection.
Pepper perfectly captures the essence of Venus's exposed form. We immediately see the legs splaying out gaily from their central point of attachment, reaching up with an abandonment and optimism reminiscent of Susan Rothenberg's *Maggie's Cartwheel*, 1981.

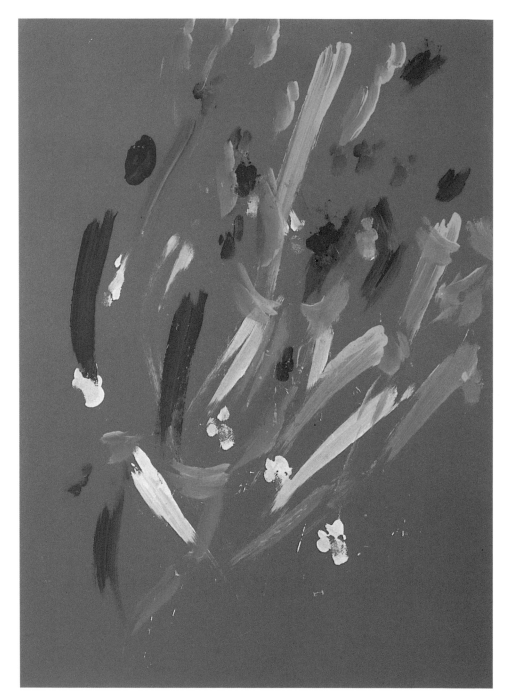

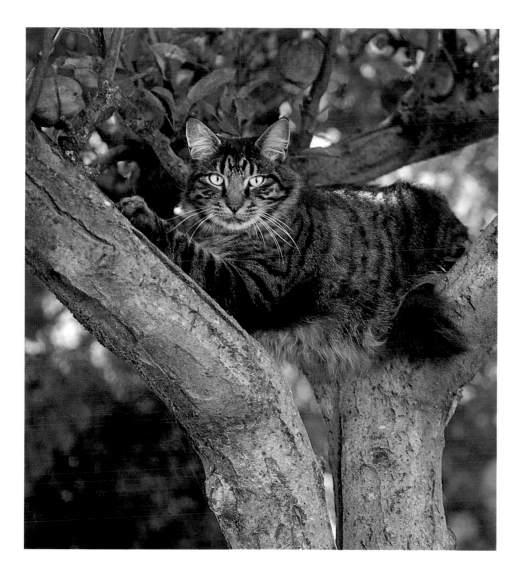

Left:
Tiger, (b. 1984), in his garden at
Königstein, near Frankfurt.

TIGER

Spontaneous Reductionist

The first thing one notices about Tiger's work is its unusual complexity.
His multiplicity of colors, intricacy of line and constant variation of stroke
angle to create texture result in paintings with a density of image unique
among contemporary cat artists. Tiger's ability to manipulate colors was
initially noticed by his owner, Elfie Henkel, in the garden of her
Königstein property near Frankfurt in 1985. At first, the kitten's propensity
to heap up fallen flowers or leaves into small piles seemed no more than a
little unusual. Even the fact that he would sometimes carry a blossom in his

Right:
Eclectic Currents, 1992. Acrylic and paste
on scratched satin, 64 x 47cm.
Dr. Philip Wood Collection, Berkeley.
Because Tiger painted this on satin it
would not yield to his reductionist inten-
tions and, despite a good deal of clawing,
maintained its basic form. This obviously
annoyed Tiger, who, in the past, has been
put off painting for months following
misguided attempts to 'save' his work.

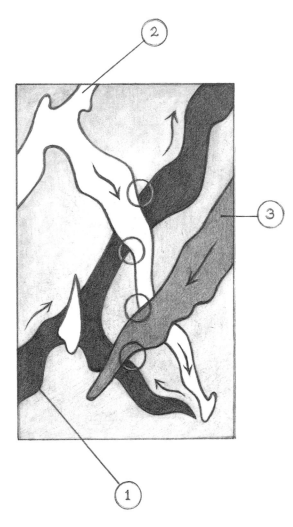

Above:
Diagram by A. Goldsworthy; interprets
the work within the context of harmonic
resonance and suggests that the painting is
a kind of map showing the energy waves
that impinge upon the cat. These waves
are represented by the three major forms
which intersect to create four primary
zones of influence.

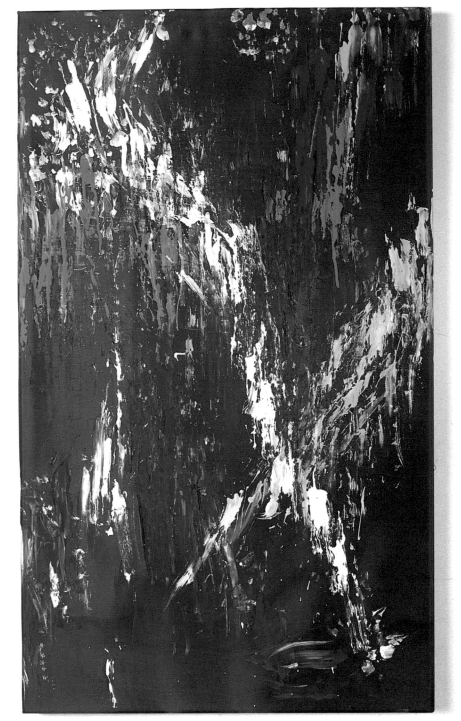

mouth from the other side of the garden to add to a pile when there were
plenty of others closer, did not strike Frau Henkel as particularly strange.
"It should have been obvious to me from the start," she said in a recent
interview, "but because he loved to pounce on his little piles and destroy
them the moment they were complete, it took a month before I realized
that each pile was made up of flowers of just one color! One pile of five or

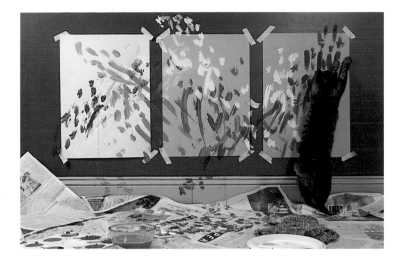

six camellias would be all red and another, all white."

What is so interesting about Tiger's recent work is that the same kittenish delight he took in destroying his flower piles, he now repeats with most of his completed paintings. But far from being simply a regression to an earlier juvenile play activity, it seems that his destruction, or rather 'reduction' has, and probably always had, a serious purpose. However, unlike other German Reductionists and Neo-Reductionists such as Puschelchen in Stuttgart and Miezekatze in Cologne, who express the

Above & below:
Tiger works vigorously, applying the medium across the three paper panels with quick rhythmical strokes that result in a pleasing textural complexity. He then removes the panels to reveal large areas of negative space onto which he paints his final motif.

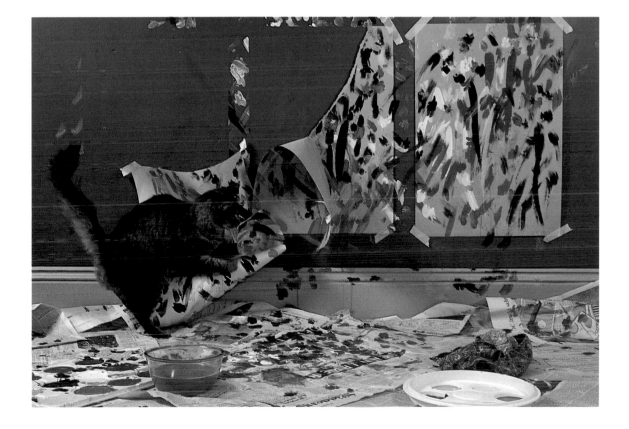

reduced image directly onto the canvas, Tiger's method relies on the reduction of the completed work to the essence of its outer form. For him, art is not the reproduction of reality, but reality discovered through its reduction. It is this that makes his work more controversial than that of almost any other cat artist. As humans, we cannot fail to relate to its delightful complexity of shapes and colors, but equally we are puzzled, even appalled, at Tiger's sudden destruction of it. But rather than struggle to grasp its significance, Dr. David Hinds, author of *The Psychology of Feline Perception* (Berkeley, 1993) suggests an alternative approach. "Once we adopt the cat's mode of concentrated vision and stare directly into the void left by the removal of the painting's center, thus allowing the remaining form which surrounds it to enter our sight peripherally, we will perhaps begin to uncover the feline perception of reality."

Below:
The completed work, *Breakfast*, 1991. Acrylic and marking powder on card and wall, 184 x 86cm. Private collection.
In *Breakfast*, we immediately feel a strong sense of sadness—of something light and fluttering having suddenly disappeared—replaced by crude and indifferent smears that suggest greed and destruction.

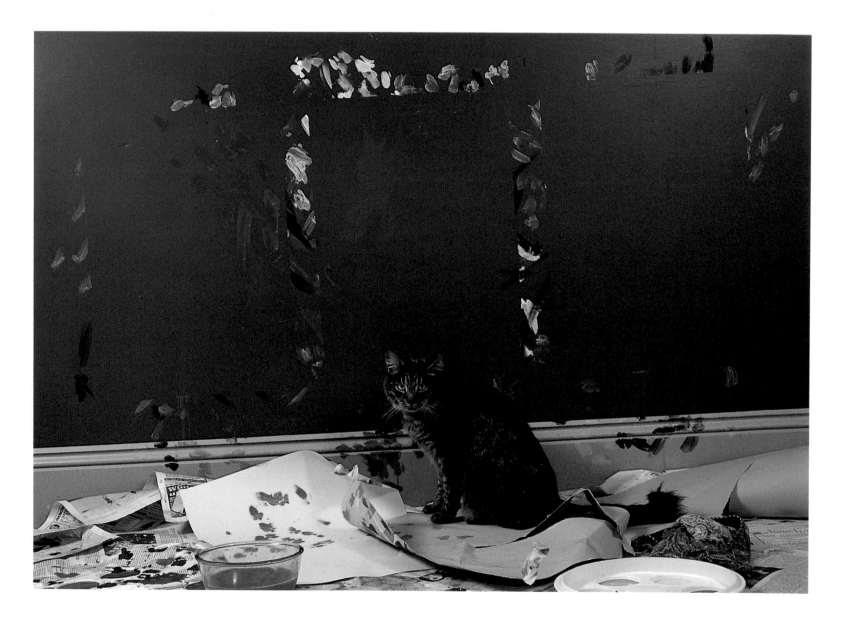

MISTY

Formal Expansionist

Misty's popularity as a painter is due mainly to the figurative nature of her images. The elegant, bi-colored forms that sometimes extend up to ten meters in length, are immediately evocative and invite a wide range of projective interpretations. In a recent work, *A Little Lavish Leaping* (page 57), the surface is heavily built up with short black verticals to produce an elongated curvilinear mass that is at once dense yet strongly nuanced with

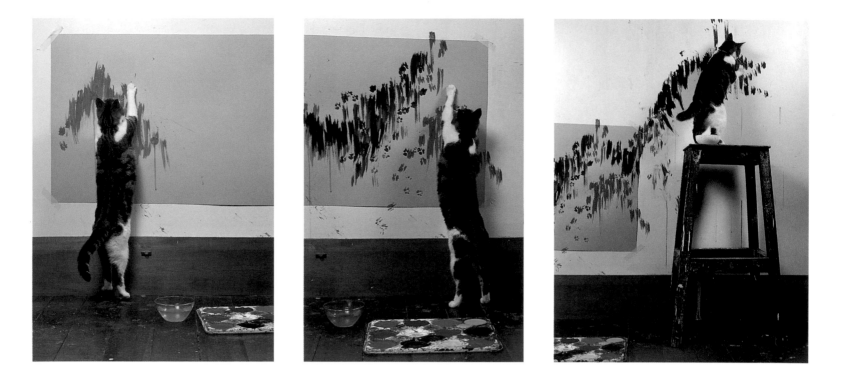

Above left:
Working with very quick strokes, Misty lays down the pink 'tension' areas first.

Above center:
The 'action structure' is composed of dense black verticals overlayed to suggest a series of interconnected curvilinear forms.

Above right:
Misty 'insisted' that the stool be placed in position so that she could complete the upper curved form to her satisfaction. Many of Misty's works go 'off canvas' and some, even go completely off the wall and onto the floor.

movement. Tension gathers at the base and builds upwards, flowing to a release (or is it a curtailment?) in the upper ovoidal form. What is so exciting about a work like this, apart from the obvious technical excellence, is its strength of imagery which, when combined with contextual uncertainty, encourages a high degree of varying interpretation.

For example, the cat's owner, Zenia Woolf, feels that the work concerns an incident in which her four-year-old son deliberately squirted Misty with the hose from the balcony. To her, each pink area describes the typical arched body of a cat as it leaps to avoid danger while the long black shape clearly represents the water snaking down from above and following the cat after its first strike, to hit it again—now more heavy and wet. Woolf feels sure the cat knew the work could not be understood if left within the confines of the canvas and when Misty was unable to mark higher than she could leap, meowed insistently for the stool to be moved so that she could complete the work. To her owner, the purpose of the cat's painting was to depict the distressing incident as clearly as she could in the hope that the owner would constrain the child from torturing her again in the future.

However, Michael Dover of the Orion Art Gallery in North York, who titled the work, has a different interpretation. He feels that it is too easy to find traumatic incidents in a cat's recent experience and use them as a context within which to interpret its art. For example, he correctly points out that Misty travelled in the Woolf's car to visit friends in Port Credit just a week before the painting was completed. On the return journey the son pulled her tail and was scratched on the wrist. Should we, he wonders, be

interested in the fact that the form of the work almost perfectly describes that fifteen-mile stretch of coastline between Port Credit and Toronto, finishing with the shape of Center Island? Certainly, cats have a remarkable sense of direction but Misty wouldn't know that bird's-eye view unless she'd flown over it or had a long discussion with a local hawk!

Dover prefers to tackle the work from a more useful, functional standpoint and feels that it clearly describes some important aspects of feline leaping strategy. The curved black lines describe the path of the leap itself. It begins with the crouched form of the cat ready to spring in the upper right quadrant and follows it down to the pink impact-position below, from which it leaps again, to land with outstretched paws, in the next position.

Local art critic Emma Way agrees, but insists the cat is leaping in the other direction and that the pink areas describe the crucial spring-off points which dictate the success of the leap. Others have seen a dinosaur galloping to the right and there are those who favor a squirrel jumping down to the left. In the end we can never be sure just what Misty intended. The important thing is that we don't stop trying to understand.

Below:
A Little Lavish Leaping, 1993. Acrylic on card and wall, 120 x 170cm. Preserved *in situ* North York, Toronto. Misty's paintings are greatly valued for their strong yet ambiguous imagery which, combined with contextual uncertainty, allow for a great richness of interpretation. The power of this sort of cat art lies in its very incomprehensibility which enables it to provoke and intrigue.

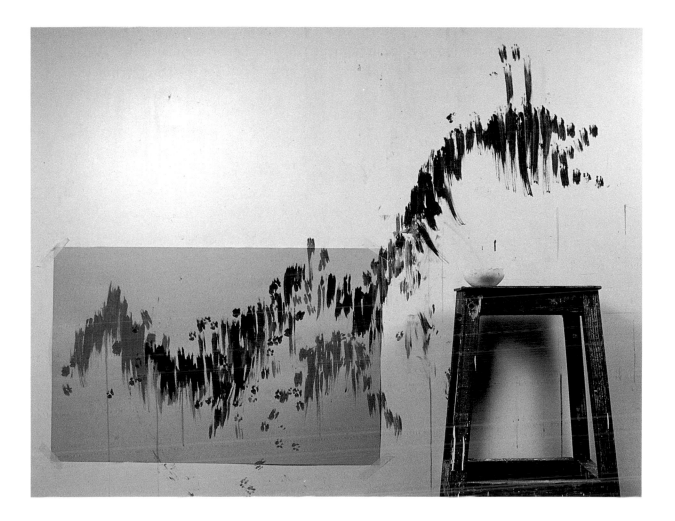

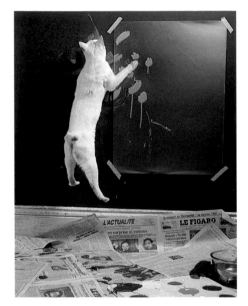
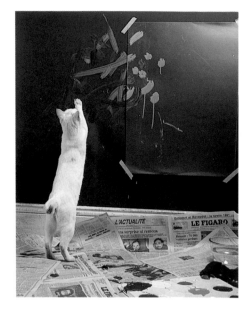

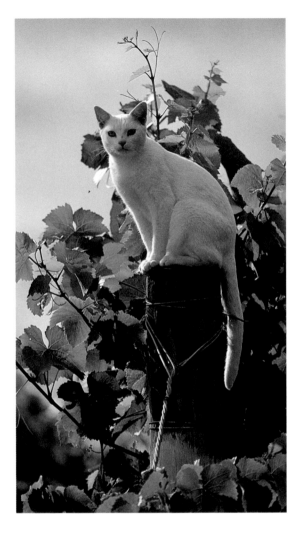

Above:
Minnie, (Minnie Monet Manet),
(b. 1984), spends a good deal of time
contemplating amongst the vines before
beginning a painting. After a two-year
caesura following poor reviews in 1988,
she now paints as often as once a week.

MINNIE

Abstract Expressionist

As soon as Minnie left Lyon and went to live at the little vineyard in Aix-en-Provence, her paintings changed dramatically, and so did the reviews. In 1988, Paul Seuphor had this to say about one of her paintings, titled *Three Blind Mice,* exhibited at the Galerie Félin in Lyon. "Three dreary monochromatic daubs with single trickles of excess paint running from each of them are evidently meant to represent blind mice. Certainly, they have no eyes. Nor do they have ears, or legs, or whiskers or anything else at all except tails. Maybe one can forgive them their difference, but where is their life? Where is the action? Where is the farmer's wife with her big knife? We could definitely do with her to finish off these pathetically uninteresting little blobs of gray."[1]

Compare that to the review she received three years later for an exhibition of her paintings in Arles. "...her work emits a luminosity that cries out with exhilaration, mystery and revelation...her many colors and directions allow us to glimpse the inner feline reality."[2] There can be little doubt that the relaxed warmth and lush abundance of Provence worked its magic on Minnie, as did a certain British Silver Spotted Shorthair tom named Pierre (Pierre Miayler), who shares her new home. He doesn't paint, but with one of their kittens selling in Japan for $20,000 recently (twice what Minnie receives for a painting), he hardly needs to.

[1] Seuphor, P. Patte-pelue. *Exhibition catalog, Lyon, 1988.*
[2] Du Mombrison, Henri. La joie au cœur. *Exhibition catalog, Arles, 1991.*

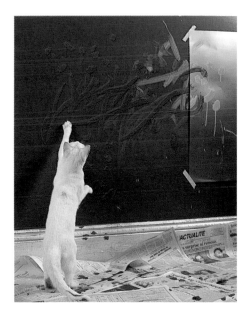 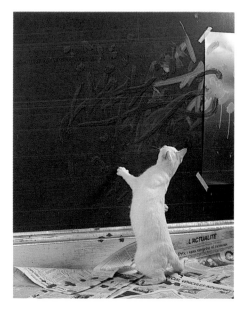

Left:
Minnie paints with enormous speed and pixie-like vigor, scarcely pausing to consider the work until it is complete. Her paintings, which contain unusual horizontal marks, refuse to be contained by the need for conventional boundaries and overflow 'off-canvas' in a vital yet balanced manner.

Below:
Reindeer in Provence, 1992. Acrylic on gold card and black wall, 120 x 180cm. Collection of the artist.

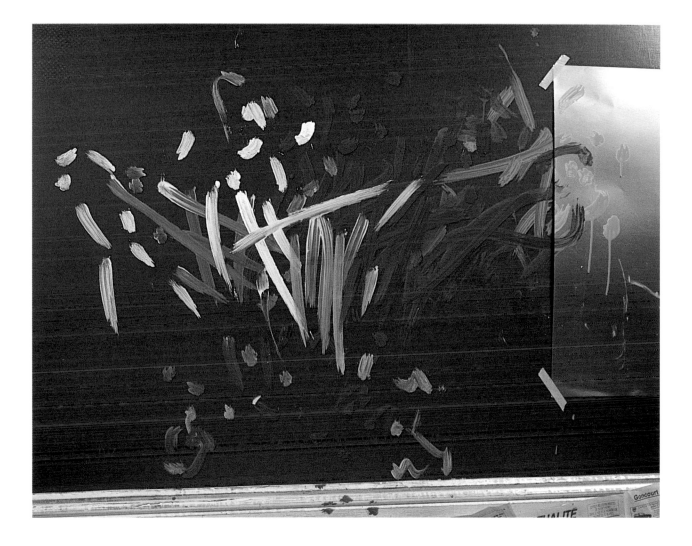

SMOKEY
Romantic Ruralist

Cats are the only animals other than human beings that regularly use drugs to heighten their aesthetic sensibilities. Smokey is no exception. His painting sessions are always conducted in a secluded part of the garden and inevitably preceded by at least an hour in the catnip patch. This explains not only the slow, almost ponderous way in which he paints, but also the remarkable depth of his pastoral vision. Of course, any artistically inclined cat living in the rural splendor of New Zealand's South Island, as Smokey does, could not fail to be profoundly affected by its clarity of light, its fecundity of image, its almost oppressive beauty.

Smokey has the ability not only to imbue his bucolic forms with elements of 'The Romantic' but also, more importantly, to maintain their dignity. We see this clearly in one of his best-known works, *Serious Ramifications* (left). "The first thing you notice about the work," writes critic Bevan Island, "is its bold regularity, its obvious symmetry. Not until

Left:
Serious Ramifications, 1992. Acrylic on board, 73 x 62cm. McGillicuddy Art Gallery, Christchurch. This study of a ram was originally titled *Ramshackle* by the cat's owner, but was later changed curatorially.

Below:
Despite the fact that Smokey (b. 1987) uses catnip or catmint (*Nepeta cataria*) before painting, her work does not reflect a psychedelic element. She seems to use it more as a way of intensifying the harmonic resonance experience which acts as such a strong stimulant to feline creativity.

Above:
Smokey, who can be seen in both pictures, studying and completing *Serious Ramifications* in the garden of his Nelson home in New Zealand's South Island. This study of Rodney, a fifteen-year-old ram, was the subject of a good deal of contention when it was purchased with public funds by the McGillicuddy Gallery in Christchurch for $6,000 in 1993.

later do we see the sheep walking. But once we do, the feeling of movement is powerful and immediate. We are able to peer through the confusion of moving limbs from a variety of revealing perspectives as it strides forward (right to left). Light flickers intriguingly as these oblique pediments divide and re-divide, impinging upon the dandelions beneath which appear to explode (implode?) under the impact. Now the four pre-eminent forms are at once the four hooves poised menacingly above; sharp, knife-like and ready to do battle with any insouciant tail or paw!"[1]

This picture has been the subject of much contention, with several reviewers taking exception to interpretations such as the one above which benefit from having seen the verifying photographs that accompanied it at exhibition. For example, as Dieter McLeavey correctly points out, "It is possible to claim almost anything for a work of art provided you can justify it contextually. If I say that the *Mona Lisa* is smiling at the ghost of her dead cat, you will very quickly find its spectral form just below her shoulder, even though you've never noticed it before. Could the fact that Van Gogh once shot a cat mean that the form in the bottom left-hand corner of *The Starry Night* is a cat sadly rubbing its eye? What is the significance of the slug-like cat in Matisse's *The Swimming Pool*? What if I told you he once drowned a sack of kittens?"[2] The point is well made. While the leap for a contextual answer, both as a means of understanding the work and relieving cognitive dissonance, is highly attractive, it cannot help but limit the scope of the painting and halt the essential process of exploration.

[1] *Island, Bevan.* Serious Ramifications at the McGillicuddy. *Christchurch Examiner, 1993.*
[2] *McLeavey, Dieter.* Strictly Ewephemistic. *Journal of Australasian Art, Vol. I, 1994.*

Above:
Smokey puts the finishing touches to
Manic Marigolds #17. He always chooses a
secluded part of the garden for his paint-
ings and lets his owner know where to
leave his paints and easel by flamboyantly
marking the spot with urine.

Left:
Manic Marigolds # 17, 1991. Scented
acrylic paste on paper, 64 x 48cm.
David McGill Collection, Wellington.

GINGER
Neo-Synthesist

Above:
Ginger, (Ginger Katdinsky Kleeché Klipt), (b.1987), a sensuous cat who sometimes relates so strongly to her paintings that she rubs against them before they are dry, so inadvertently destroying them.

Despite showing early signs of an aesthetic marking ability, Ginger did not paint until she was four, and then only as a result of careful encouragement from her owners, Colin and Mary McCahon of Manchester. Her wallpaper scratchings had always exhibited a delicacy of line and a marked appreciation of surface texture, but she showed no inclination in those first years to explore the use of marking media. It was only after Colin McCahon had given her numerous demonstrations of how the damp sand in the litter tray could be used to mark the wall (thus proving to her that painting was simply a natural extension of her tray marking), that Ginger began to tentatively use the rich variety of scented acrylic pastes the

McCahons always left out for her. Now she is prolific, painting almost every day and often at night. Once a painting is complete, it is not removed, but left to act as a reference point for the next. In this way, her art becomes developmental, ranging widely over a variety of appropriate surfaces, including windows, curtains, tables, chairs and the occasional pot plant. The finished works are to be walked past, viewed sequentially like a story rather than experienced as a fixed single view in a fixed single moment—each painting existing as a memorable point on a continuum through which the identity of the feline self is slowly emergent.

PRINCESS

Elemental Fragmentist

Princess is one of a small number of Elemental Fragmentists, a school of mainly Siamese and Rex painters, whose work is typified by an economy of line and form that conveys only the essential elements of just one part, or fragment, of a subject. This is perhaps the hardest of all feline art to understand and the most difficult to recognize in its formative stages. It was only after Princess had been painting for two years that her owners, Larry and Agnes Martin of Elmhurst, Chicago, realized that all the elements which characterize her present style were apparent in the very first scratches she had made as a kitten on her wooden cat door.

In her more classically minimalist works, Princess uses a set number of angled to vertical strokes (3:2 or 2:3) in a multiplicity of combinations that enable her to explore a wide variety of subjects. We see this clearly in *Amongst the Pigeons* (left), a very early scratching she made on the lounge wall, which has been interpreted as "...perfectly encapsulating the essential

Far left:
Amongst the Pigeons, 1988. Marks with claws on painted fiber-board wall panel, 48 x 72cm. Private collection

Left:
Princess, (Princess Winklepaw Rothkoko), (b. 1986), will often experiment with sounds during a painting session. The flute mode with a bossa nova beat on this synthesizer is her favorite.

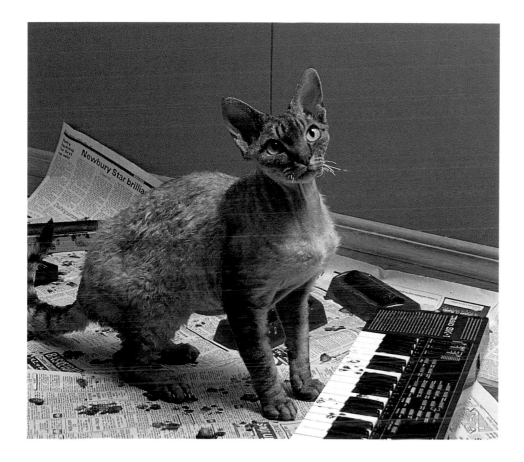

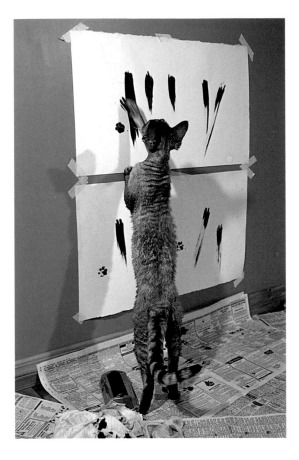

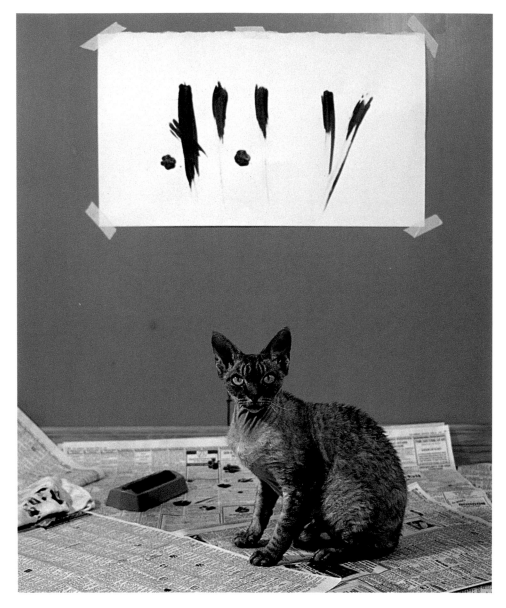

Above:
Princess often works with an upper and lower 'canvas,' using the lower area for preliminary sketch work before proceeding to the final work above. She usually destroys the lower work, but in some cases, prefers it to the upper one which she will claw down instead.

Above right:
Regularly Ridiculed Rodents, 1993. Ink on paper, 52 x 83cm. Patrick Hitchings Collection, Melbourne.
Everything in Princess's work is narrowed to almost totemic simplicity.

elements of the hunted bird's footprints as it makes its final terrified contact with the ground."[1] Other works are not so clear. *Regularly Ridiculed Rodents* (above), for example, has been variously interpreted as depicting two ostracized rats, the essence of cockroach, a functional detail of her paint roller, and, as one would expect, a host of black magic symbols.

Of more interest perhaps, is why she paints these images. Certainly, her art seems to spring simultaneously from prolonged periods of contemplation, periods when she insists on positioning herself in exactly the right place in the room. Does this mean that Princess's elemental forms provide her with the means to plumb the depths and complexities of her own responses to the resonating forces she seems so intent on finding? For although her intention is often unclear, there is a strong suggestion of

[1]*Flavin, Don.* Five Feline Fragmentists. *Exhibition catalog, 1992, Seattle.*

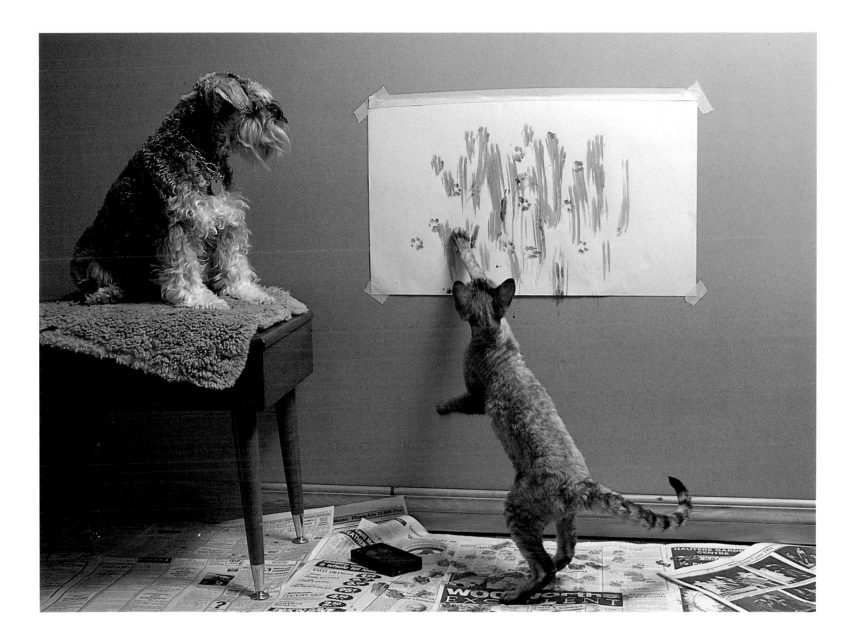

external forces being internalized and translated into a meaningful image.

Does the fact that she is inclined to become sulky and peevish if anything in the room is moved prior to her beginning a painting mean that her deceptively simple structures have to do with complex resonating influences and energy lines that involve ambiguities, paradoxes and tensions arising from the position of movable objects?

Whatever the answers, there can be no doubt that Princess, the cat and the painter, manifests a curiously intense subjectivity, a critical awareness of being both the receiver of energy and its translator. But it is an open subjectivity, a shareable experience. As she rubs up against our legs, purring, at the end of a particularly protracted painting session, we are left in no doubt that her unique interpretations are meant for us too.

Above:
Bounding, 1991. Diluted ink on paper, 64 x 84cm. Museum of Non-Primate Art, Tokyo.
Princess's painting of Boris focuses on the green tag hanging from his collar. The repetition of green dabs and streaks amongst the light brown verticals (which must represent the dog's fur), gives an immediate sense of the tag flicking about as the dog moves, thus capturing the essential nature of canine cavorting.

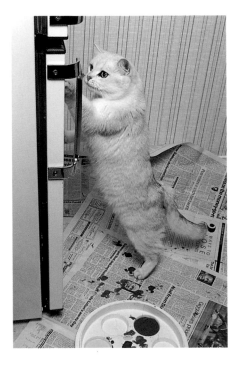

Above:
Charlie, (b. 1985), who lives in Sydney, Australia, does all his painting on the refrigerator where the smooth surface allows him to spread the paint quickly and achieve a lively spontaneity.

Right:
The Wild Side, 1991. Acrylic on enamel, 63 x 101cm. Collection of the artist.
Cats use their peripheral vision far more than we realize. This is why they will suddenly look intently in one direction when there seems to us to be nothing there at all. What they are doing of course, is using their more color and movement specific peripheral vision to study objects by looking sideways at them. (You can tell which side by noting the direction of the tail tip —it points in the opposite direction to the side of vision). Charlie has just completed an impressionistic work in which the dish-towel appears as a major motif, and he can be seen checking his subject peripherally.

CHARLIE
Peripheral Realist

When Charlie, (Charlie Erwin Schrödinger Jones), was six months old, he was inadvertently shut inside a refrigerator for five hours. Somehow, that event seems to have been a turning point in his life—transforming him virtually overnight into a prolific painter. Many human artists have attributed the sudden urge to express themselves artistically to an emotionally shattering event in their early lives. Both Van Gogh and Picasso suffered pre-pubescent claustrophobic traumas, and it seems possible that Charlie became totally fixated with painting on the refrigerator after being 'punished' by it, in the same way as Picasso's early experience may have been responsible for what Robert Hughes has described as "...the intensity with which he could project his fear of women..."[1] In both cases, their work seems more of an exercise designed to explore, and thereby come to terms with, the object of their disaffection, rather than to celebrate its existence. Of course, their paintings may express a degree of triumphal ascendancy on occasions, but if this suggests celebration, it applies to the successful subjugation of the object rather than to the object itself.

This is not to say that much of Charlie's work fails to consider other objects or states, any more than one would suggest Picasso deals exclusively with subjects that stir his misogynistic tendencies. But we must recognize the fact that, whatever Charlie chooses to paint, he paints it on the refrigerator—the cause of his trauma. One suggestion is that he may simply prefer its smooth surface because it suits his technique, but there are other smooth surfaces, such as the dishwasher and kitchen cupboards to choose from. Another possibility, put forward by psychologist Lyn Ng of the Animal Esthetics Department at Stanford, is that he is marking the refrigerator as a way of asking to be fed. However, Charlie's food is kept in the refrigerator in the cellar, besides which, he meows very loudly when he's hungry.

By painting on the refrigerator, Charlie is most likely doing one of two things. Firstly, he could be trying to change the physical appearance of the original trauma object (which he is forced to live with), thus disguising it and rendering it less powerful, in much the same way as Picasso applied cubist abstractions to female nudes for similar reasons. Alternately, he could be attempting to 'move' the offending trauma object by painting a motif from another part of the room onto it and then, by looking at it peripherally, make it appear to move suddenly in relation to the original position of the motif. Either way, he is able to gain power over it, which must surely be why he paints it.

[1]Hughes, Robert. The Shock of the New. *London, Thames & Hudson, 1991.*

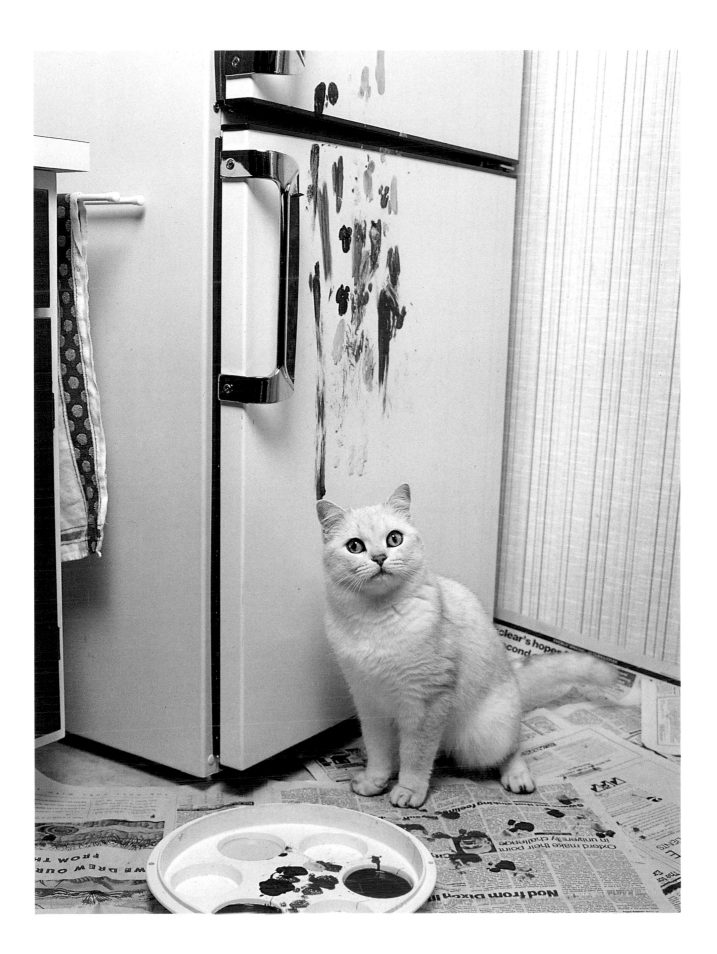

BOOTSIE

Trans-Expressionist

Bootsie was neutered, had his tail badly singed by the heater and was sent to a boarding cattery, all in one week at the end of 1989. It was the same week his owners moved house and he was caught (by the dog), attempting to steal the neighbors' half-frozen turkey roast. You'd expect most cats to be subdued by that kind of trauma combination, but not Bootsie. He thrived on it. In fact, it was at the cattery, in Rolling Wood near San Francisco, where they have a creativity program for cats, that he was introduced to painting. Being Bootsie, he took to it at once and has never looked back since. He has had five exhibitions in a little over four years and to date has earned in excess of $75,000.

To watch him paint is pure delight. As soon as the easel is put up on the lawn and the paints are laid out next to it, any hint of feline disdain, any trace of detached hauteur, vanishes completely. He almost pounces on the paint as if he must trap its fleeting vibrance before it escapes, and the moment it is on his paw he springs up to apply it. Consideration appears minimized, while concentration is intense and the strokes are vigorously rhythmical. The process seems to be designed to let body-action fully enter as a composing force, to dictate formal appearances. There is also an obvious intent to lose (loose) self in the work, not holding on to a conscious design, but repeating the strokes as a rhythm, often accompanied by purring which is common among cats who use a high degree of engagement with bodily process while painting. Equally, he may yowl menacingly at the canvas, then suddenly attack it with a quick stroke of paint and spring away as if, in that one decisive action, he had somehow breathed life into an evil force—created a monster that could reach out and grab him by the paw.

The vitality of image that results from this vigorous style can be clearly seen in *Parrot Time* (right). Critic Alfred Auty describes it as "...a poignant expression of nature's inherent dichotomies [where] one is immediately caught up in the primal duality of fight and flight. Red, yellow and blue, slightly angled, slightly curved strokes are laid close together with perfectly controlled flicks of the paw that at once suggest a frenzy of fluttering feathers, leaping upwards, spreading outwards; wing(s) beating—Color! Light! Life! Liberty-within-reach—almost, for now the dominant overlays of negating black which trace the elegant curves of the covetous paw, intrude with dazzling speed to wreak their cruel havoc. Delicate smears of white (fluffy down?), are drawn (ripped) diagonally across the image,

Left:
Bootsie, (b. 1988), uses a vigorous, sometimes aggressive style to explore his inner feelings and perceptions. He won the Zampa d'Oro (Golden Paw) award at the Exposizione dell'Arte Felino in Milan in 1993 and was runner up in 1992.

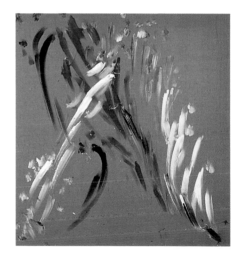

Above:
Parrot Time, 1992. Acrylic on card, 75 x 72cm. Dr. Philip Wood Collection, Berkeley.

intentionally destroying its integrity and leaving in its place a trembling, all-of-a-twitter confusion. This is a powerful work, for although drawn in by a strong narrative factor, we are nevertheless denied a final dénouement, and so left feeling uneasy and perplexed."[1]

In a recent interview, Bootsie's owner described him as "...liking to leap about and put different colors all over the place without much caring how he does it." However, Auty feels that "...this seemingly carefree 'non-serious' method conceals a deeper concern. It is not the content of life which he paints," he explains, "but the experiential feel of its rhythm. The feel for instance of the unique energy at the point of harmonic resonance; of its intensity registered all-at-once, pre-edited, as a perfect liaison of kinetic forces which derive from the slightest of actions, the most minimal of thoughts."[2]

Bootsie's method of achieving this integration is flamboyant and full of an idiosyncratic concern that typifies many of his recent works. The confrontational blacks of *Parrot Time,* for example, are echoed in his well-known *Cocking for Cockatoos* (right), in which a long-nosed green dog

Below:
Bootsie in full flight during painting of *Hands Up! Mr. Rooster,* which sold for $15,000. Note the rough sketch he made for this work on the back of the canvas.

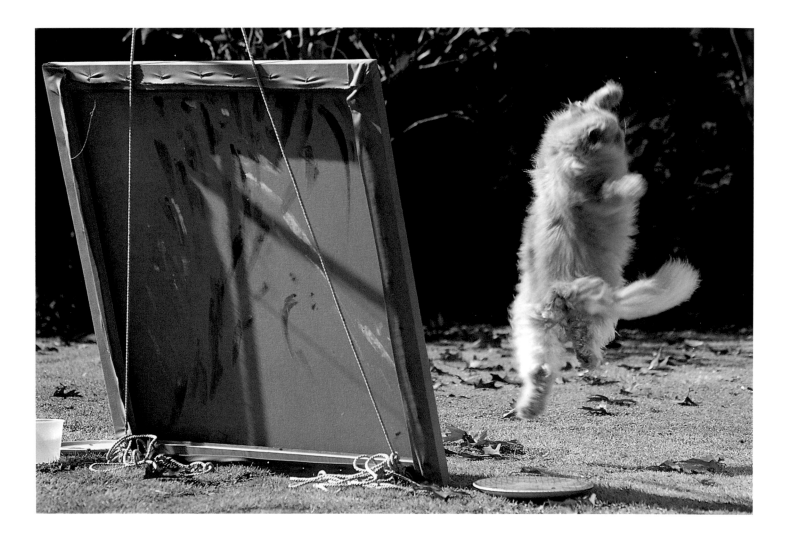

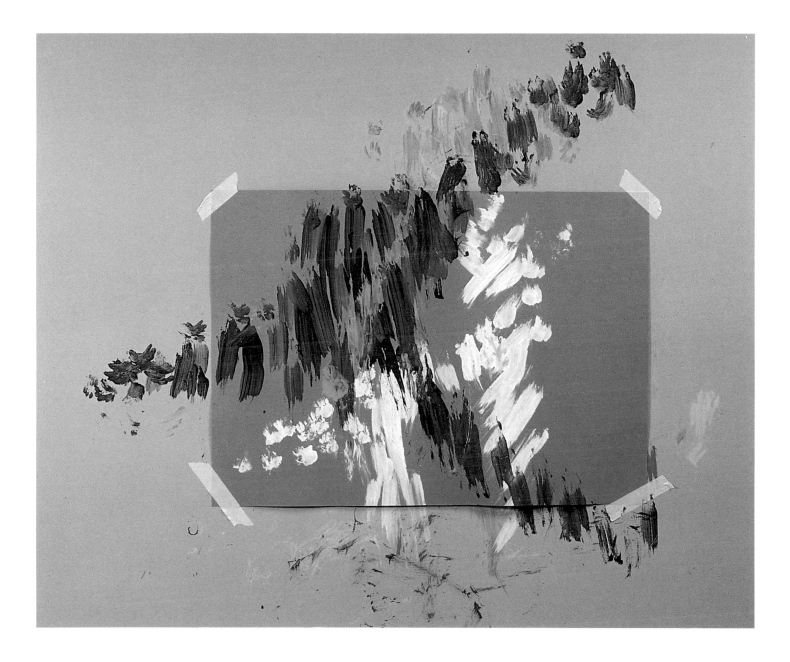

attempts to urinate (yellow), on a small flock of low-flying cockatoos (white). The inner message in *Parrot Time* is perhaps more obvious, but *Cocking for Cockatoos,* with its clever suggestion of canine incompetence, gains rather than loses by not being overly pedantic.

Bootsie refuses to be trapped in a recognizable style, but the strong physicality of gesture which tended to dominate (and perhaps limit) his earlier work is increasingly replaced by more tangible and delicately controlled marks that help to soften and add meaning to his less subtle gestures. This must enable him to explore his feelings and perceptions in greater detail and so arrive at a more satisfying understanding of his own unique place in the world.

Above:
Cocking for Cockatoos, 1993. Acrylic on card and plaster board, 110 x 95cm. Scraatchi Collection, London. Bootsie's painting has a refreshing rawness which enables the viewer to experience the physicality of the artist's deep relationship with process.

[1] Auty, A. The Feline Procrustean Ethic in Trans-Expressionism. *Paper delivered to the annual conference of the centre de recherche dans les arts graphiques félins, Paris, 1993.* [2] ibid.

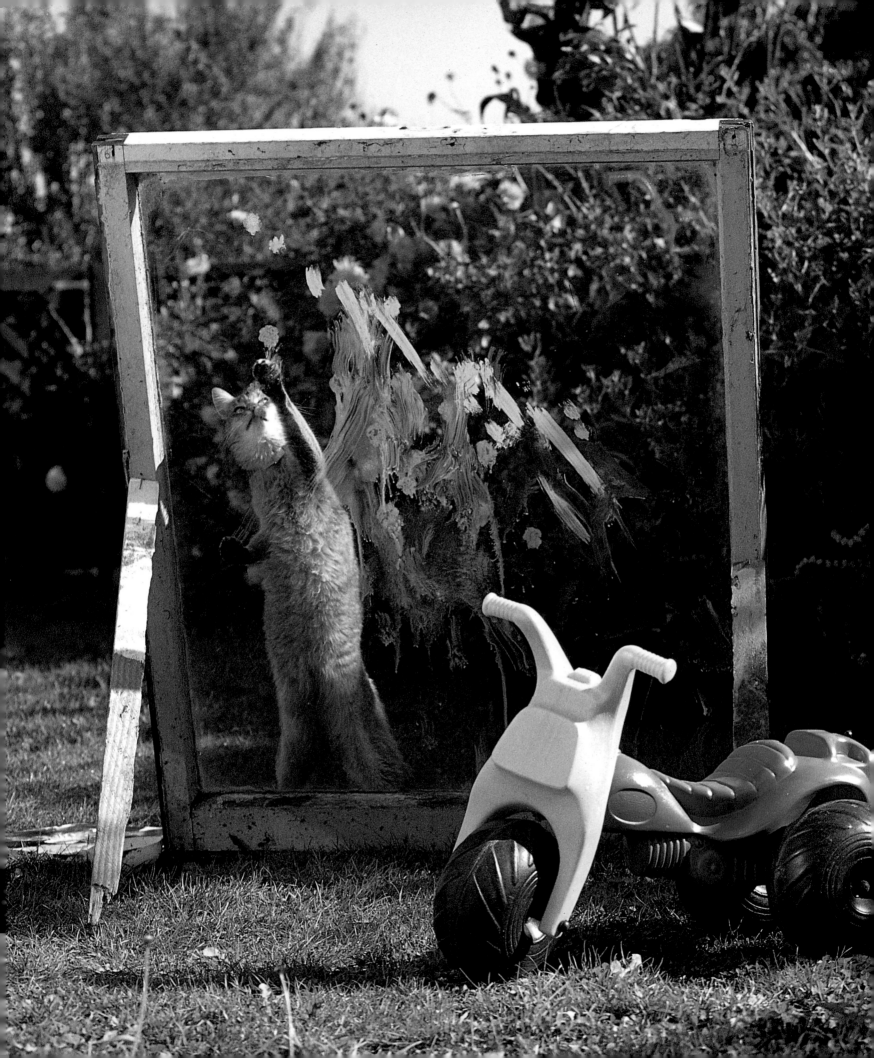

Left:
Rusty, (b.1986), sporting a rather painterly nose, relaxes after an hour-long session at the glass easel.

Far Left:
Blue Bike Blues, 1990. Scented Acrylic on glass, 98 x 78cm. Dr. Pat Morris Trust, Ascot.
Like most Psychometric Impressionists, Rusty prefers to work on glass so he can keep in constant touch with the object and allow the essence of its 'significant past' to pervade his sensibilities as he paints.

RUSTY

Psychometric Impressionist

Psychometric Impressionism involves the creation of images which reflect, not the appearance of a particular object, but rather the situations or locations the object has been involved with in the past. In order to create such a work, the cat will spend a good deal of time sniffing, patting and rubbing against the object or animal whose psychometric impression it wants to convey, before it commences its painting. Because of their psychic abilities, cats are highly adept at this form of expression and Rusty, an Abyssinian who hails from Edinburgh, along with Muscat in Paris, is one of the world's leading exponents of the art. Like Muscat, he is highly sensitive to small changes in static electricity and therefore something of a premonitionist, often being

Above:
Rusty appears to have accurately captured
the nuance of an accident two weeks pre-
viously, when the bicycle his owner's five
year old was riding hit a rock and cart-
wheeled into a paddling pool.

Right:
In this inverted psychometric impression
of a Russian doll, Rusty applied acrylic
powder to the condensation on the win-
dow at night and now adds further detail
by finely scratching the dried paint.

able to accurately predict certain events before they occur.

Rusty's choice of subject matter seems to be contingent upon whether it has some special significance for him, though this is not the aspect he expresses in his paintings. In *Blue Bike Blues* for example (page 76), he chose a bicycle that a child had used to deliberately run over his tail the day before. However, it is not the bike nor this event which he explores in the work, but rather an incident which occurred while he was away and his owner tripped over the bike when carrying two large bags of bottled beer. In the ensuing furor, the bike was hurled onto the neighbors' roof where it unfortunately became entangled with their TV antenna. If they (the Australian neighbors), had not been watching a live telecast of the cricket from Sydney at the time the painting may never have happened. Certainly, the bike wouldn't have ended up impaled on top of his iron gate where Rusty couldn't fail to notice it on his return home from the vet. But whether or not this prompted him to paint it, the remarkable thing is that even though he never saw the bike on the antenna, he not only rubbed himself against the bike, but also spent a good hour rubbing against the neighbours' antenna before he began to paint.

4 | Other Forms of Artistic Expression

The number of domestic cats actively painting in the world today is minuscule, maybe a few hundred at the very most out of the estimated two hundred million currently living with human beings. There are, however, many more hundreds of cats who use other forms of artistic expression and no survey of this kind would be complete without some reference to them.

A few cats continue to use types of process art such as sculpture or scratch-forms in addition to their painting, but for the majority, the various non-painting techniques usually represent the first stage of their artistic growth and cease to be developed once painting has become firmly established. It is true that some cats begin to paint with little or no preliminary exploration of these more rudimentary forms but, for most, they represent the essential initiating element and are of great significance in determining the future direction of their creativity. Indeed, it is by examining these initial efforts that we are able to gain not only an understanding of the genesis of the primal feline aesthetic gesture but, by inference, possibly move closer to an appreciation of our own artistic beginnings.

Left:
Maxwell with *Gerty*, a work in progress. Clever use of negative space between the loosened brocade and its upper support seems to imply an open mouth, while his intricate claw work on the adjacent apex gives a subtle indication of wet nose catching the light. Two vertical threads hanging from the lower jaw now immediately suggest drooling and the whole work (including the legs) almost certainly portrays the frontal aspect of Gertrude, the St. Bernard with whom Maxwell shares his home.

Right:
Interpretive diagram by R.A. Scull, 1993.

Above:
Strontium with *Passing Through*, 1990. Appropriated couch, 56 x 33 x 42cm. H.Busch Collection, New Zealand. One interpretation (diagram left), suggests a facial form is developed as the predominant territorial sign: (1) eyes, (2) nose, (3) front legs.

The widespread domestic use of upholstered furniture from the turn of the century on, has had a profound effect on the development of a feline aesthetic. Unlike loose materials such as curtains, tablecloths and the like, the fabric covering furniture is stretched firmly over padding and held in place by wooden supports which enables it to be progressively degraded in a controlled manner over a long period of time.

A cat making a territorial mark on a tree trunk leaves scratch marks which, with repeated marking, become deeper and bolder rather than more complex. However, the cat, marking on upholstery very quickly sees its initial sign changing as progressive scratching degrades the integrity of the fibers. Egon Lübel, writing in *The Biology of Feline Art*, describes what happens next. "Now its thin vertical mark has become something

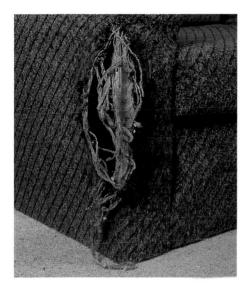

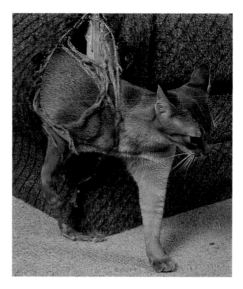

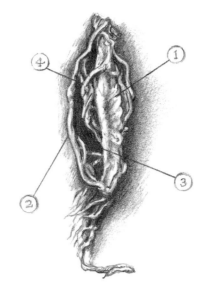

Above:
Bonny, *Come On In*, 1990. Appropriated lounge chair, 92 x 89 x 78cm. Private collection.

Above:
Clyde interacts with his sister's sculpture, allowing his whole body to become implicated in its heavily nuanced form.

Above:
Interpretive diagram by Peter Muxlow:
1. Tail form.
2. Erogenous edging.
3. Ovoidal aperture.
4. Restrictive vine forms.
"The synthetic fiber has been carefully frayed to resemble the texture and color of a cat's tail in the upright welcoming position—inviting, yet guarding the entrance beyond. However, this controlling tail is itself compromised by restrictive vines so that the whole erogenously edged aperture hints at pleasure tinged with the possibility of entanglement."
Muxlow, M. *Clawstraphobias.* Exhibition catalog, Drexel Gallery of Non-Primate Art, Philadelphia, 1992.

else—a hole, a shredded slit, or maybe a bulbous profusion of foam. For some cats, a point comes when it accepts this new construction as its own mark and, using its innate ability to copy, attempts to repeat it. This is the very beginning of representational art—the dawning of an artistic sensibility. Then, in the process of trying to replicate [its new mark], another begins to emerge from the increasingly tattered fabric, and now our copying cat must make a decision; which will it duplicate? Which does it prefer? This is the moment of its first truly intentional aesthetic gesture."

Although the techniques used in these upholstery works may look simple enough, the older, less flexible fabrics and coarse horsehair stuffings involve considerable modelling problems and some cats have to resort to binding fibers together excrementally, or add the required textural interest with salivary deposits. Owing almost entirely to owner ignorance, many cats are not given access to paints at this stage and forced to continue with soft sculpture. For them, the increasing use of furniture made of easily worked synthetic materials and simply degradable, yet coherent foams, has, on the surface, been beneficial. But these modern mediums are not without their problems and it is now becoming progressively difficult to distinguish between serious attempts to develop new signs which make full use of the feline aesthetic and what Lübel describes as "the merely dilettantish reliance on the occasional dramatic effect."

However, much of this upholstery work is not without merit and a recent eagerness by cat artists to find sculptural equivalents for feline experience has seen the construction of elegant works which draw their

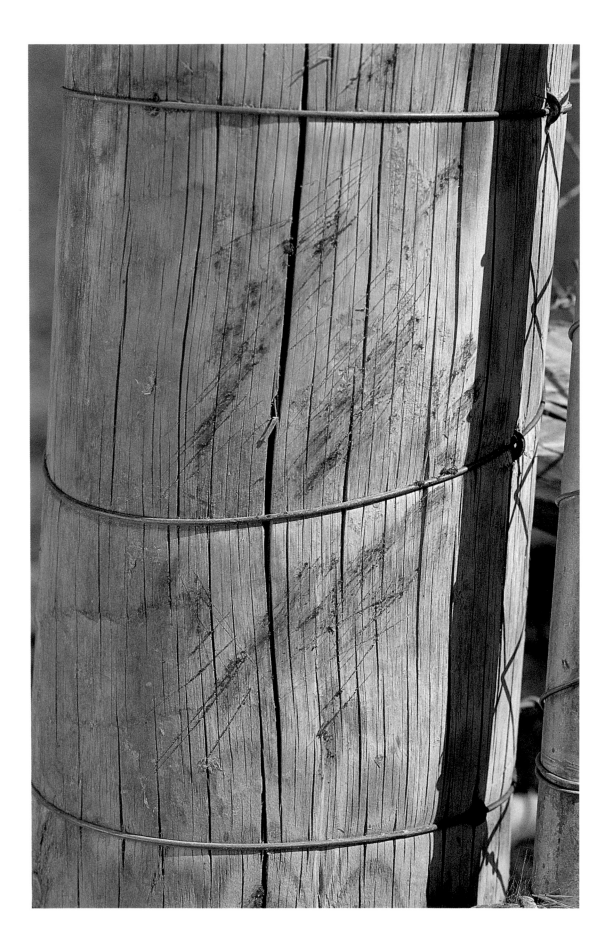

audience (other cats) into the work by actual physical participation.

Of course, transmutable media like upholstery are not crucial to the development of a cat's creative ability. Marking on a dense substance like wood, provided it is done over a long period and in compliance with the two natural laws which govern effective territorial signing, can also initiate an aesthetic sense. To be powerful, a territorial mark must first be repeated as often as possible in the most highly populated areas so it becomes widely known amongst a given population of cats. Secondly, it must be distinctive, yet still easily recognizable as a territorial demarcation. A cat using such a mark in this way will be rewarded with a well-secured territory. Each time it makes its special mark, each time it sees it, the cat feels secure and is encouraged to repeat the process. Gradually, the artist becomes better at it, is able to do it more quickly and learns where it is most effective. Eventually, this evolving aesthetic judgement and technical skill may develop into the ability to make representational marks.

This seems to have been the way in which Angel, a ten-year-old American Havana Brown who lives in Kilcullen near Dublin, slowly realized her ability to make imitative scratchings. *How Now?* (left) scratched on a round wooden gate post is typical of her considered Land Art style. Inspiration is almost always another living thing, in this case Isabella the Jersey cow, but she has also completed separate invertist scratchings on a motor mower, a sheep's skull and a discarded white plastic potty, *Bottoms Up,* 1991. Her relationship with Isabella spans her entire life. As a kitten, she delighted in jumping at the cow's swishing tail and later found the floppish quality of the lightly patted teat irresistible. Inevitably, she uncovered the secret of milk, but before she could work out exactly how to take advantage of it, Isabella sat on her. For nearly a minute, the whole of Angel's little body was completely enveloped in the warm rubbery folds of Isabella's stifling udder.

This experience was profoundly formative for the young artist. The resulting relationship with Isabella is obvious in many of her recent scratchings such as *How Now?* and *Over the Moon,* but the lack of trust it engendered finds expression in her approach to many other subjects, too. In a work clearly intended to depict the neighboring Alsatian-Collie cross, for example, she carefully shredded the front of a cane chair to almost perfectly replicate a side view of its long fur. When, after six months, the work was finally completed to her satisfaction, she urinated all over it and never touched it again.

While aesthetic clawing is a relatively common feline creative technique, one must be careful to distinguish between the irrelevant and destructive scratchings that are occasionally exhibited by ignorant owners in the hope of financial gain, and those scratch-forms which demonstrate a high degree of considered artistic intent. There can be little doubt of this

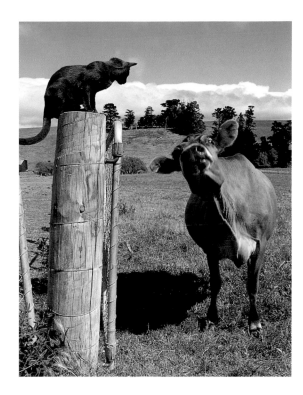

Above:
Ever since the udder incident, Angel's relationship with Isabella, the cow, has been tinged with a degree of revenge. Each day Isabella must pass through several gates on her way to and from milking. Angel takes this opportunity to jump onto her back and explore the finer textural details of her bony hide. This infuriates Isabella who tries everything, including a kind of bovine hypnosis, to stop her.

Left:
How Now? 1993 Scratched gate post, 151 x 28 x 28cm. Owner's collection. Angel's feelings towards Isabella are clearly stated in this recent work. "The post itself seems representative of both cow and relationship. Encircling wires bite deep into the wood, subtly bulging it out like an abundant udder, while deep vertical fissures spoil the surface and threaten its integrity. The claw marks, with additional cow dung to add contrast, are drawn at an oblique angle in four distinct groupings, which when viewed as the four corners of a three-dimensional box, equate with the four hanging teats of the udder. Now the deep gouging scratches, which may have previously been considered over worked, take on a new significance." (Exhib. Catg.)

when the work has taken a long time to complete, especially in the case of a chewing or mouth sculpture, which is usually the product of great dedication by a cat with a determined sense of purpose. *Bad Cat* (right), by Fritz (Fritz de Flayed-Mouse Fischl) of Los Angeles, falls into this category.

What immediately strikes the eye is the bold use of negative space to create the image of a cat (tail upright, front leg forward) walking straight towards us—striding defiantly through this mean, light-slitting, mass produced techno-barrier that curls back as if melted by searing heat. Fritz is not swayed by any promptings of feline Zeitgeist and while his work arguably borders on the Avant-Grunge with its celebration of second-degree white trash, it nevertheless brings into focus the artist's serious concern with the confining effects of modern technology on the domestic cat. Fritz's death in 1993 (electrocuted while completing a reconstructionist sculpture on a TV cord), was a great loss to the movement, but he leaves behind an impressive œuvre including his well known Barbie chewings, *The Zen of Ken*, 1991, and *The Sound of One Leg Flapping*, 1992.

Cats possess an exceptionally flexible skeletal structure and a well muscled body which enables them to adopt and hold a large repertoire of poses for long periods of time. Despite this, surprisingly few choose body sculpture as a mode of artistic expression. The few cat owners who insist otherwise often fail to distinguish between their cat's rehearsal of the extremely slow, controlled movements necessary for hunting by stealth and genuine examples of performance art which involve frozen body positions specifically designed to effect a change in the viewer. These performances are usually put on for the benefit of other cats and, although they may occasionally display for mice and even birds, they seldom bother

Left:
By mimicking the pointy and whiskered nature of a mouse's nose, this cat is able to impress her viewer with an impassioned characterization of the victim position.

Below:
Misty uses her own body to make a living sculpture of a mouse, thereby creating an empathetic, one-to-one communication between artist and viewer, cat and mouse.

with dogs, who for some reason become highly agitated and often aggressive when viewing this form of art.

Accentuation is a type of aesthetic expression which can present difficulties in interpretation because of its similarity to advanced territorial marking techniques. Unlike the various scratch-forms which create new images by degrading and reforming an appropriated article, accentuation is a kind of decoration which involves the application of a medium to another object or artwork in order to enhance or accentuate some aspect of it. There is no easy method of distinguishing between gestures of accentuation and signs made to denote ownership but, generally speaking, the former are a good deal more complex than territorial marks need to be. A real problem emerges, however, where two cats decide to engage in competitive marking, each one adding a mark to counter the other's until the object is covered with an often intricately impastoed effect. In such cases it is crucial to have actually witnessed the painting process in order to ascertain whether or not it constitutes a valuable work of accentuation.

Above:
Merry Fishmess, 1989. Acrylic on wooden fish, 72 x 39 x 37cm. Private collection.

The status of these two artists is enough to confirm that this adornment of a wooden fish constitutes a genuine work of decorative accentuation rather than being the end product of a competitive territorial marking session. Julie (right) is well known for her clever accentuating daubings on obsolete Italian nautical charts and Schnabley Puss, for his striking mixed media metamorphoses involving fish paste and turkey bones on broken milk saucers.

Above:
The cat's ability to draw clear lines to accentuate the territorial position of its feces is constrained by unsuitable marking media such as coarse litter (page 27).

Cats with access to fine damp sand are better able to produce a multiplicity of well-demarcated grooves and interesting textural effects which are more likely to stimulate the development of an aesthetic response.

The classic litter-tray pattern involves two or three deep grooves arrowing towards the feces. Obsessive marking by insecure cats often results in their creating new curved lines to accentuate their deposits.

Above:
A simple, somewhat overworked curvilinear design with the beginnings of a second curve which traces the first, and shows an incipient ability to copy.

Above:
A more complex pattern of finely executed curves which effectively incorporates the bottom of the litter tray into the overall fluidity of design.

Above:
A very advanced, swirling (possibly tail symbolist), motif with interesting (w)hole effects. A well-balanced composition—the work of a creatively advanced cat.

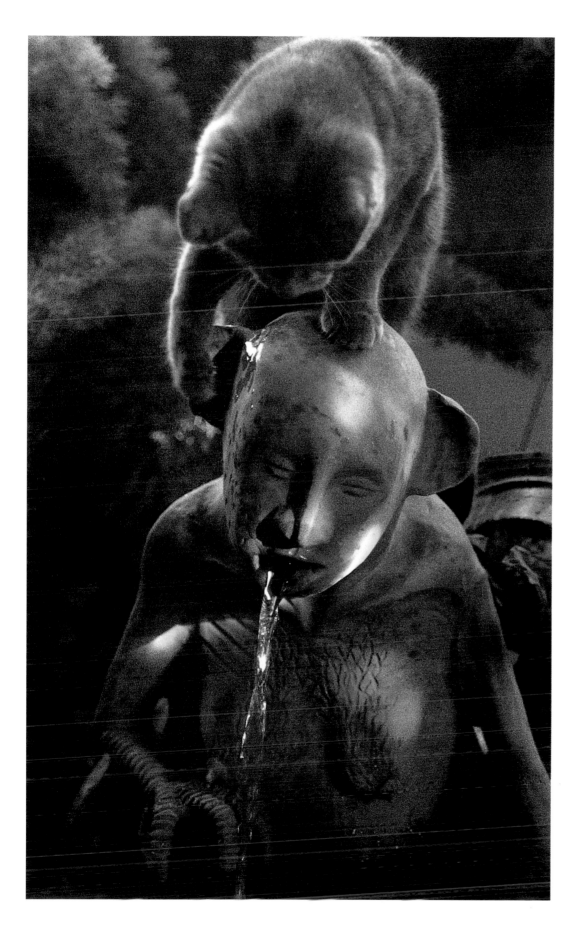

91

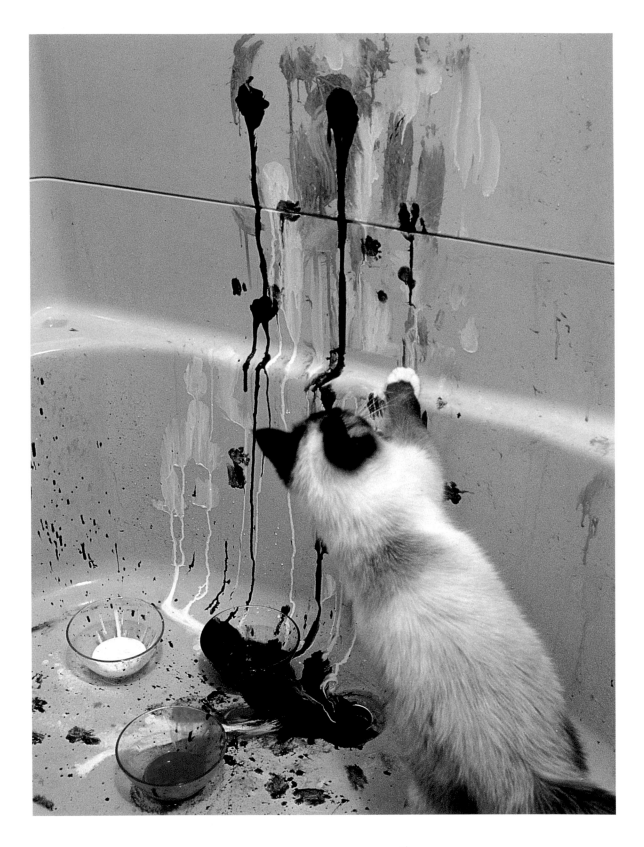

Above:
Fluff, *Untitled*, work in progress, 1994.
Playing with paints in the bathroom often
leads on to serious paintings like this.

Above:

Many cats play with wool but Fluff uses it to construct creative installations. Her technique has developed rapidly over three years and as her owner notes, "She uses less wool but more colors than she used to and now she makes really tight knots and goes all over the place with it." These remarks are substantiated by critic Christine Carswell who reviewed the work in *Cat Art Today*. "Fluff demonstrates a greater precision of detail and economy of means than in her formative installations. The strongly accented and tightly (cruelly?) tangled nodes of intensity are finer, while color and shape have a less formal coherence which contributes to the eloquence of these shapes that are highly suggestive of deceased, or nearly deceased, prey. The disturbing presence of these ephemeral constructions intrude into her living space and suggest an imposed sense of ceremony which has been an integral feature of many of Fluff's works. If excitement, rapture and delectability are woven into the texture of this installation, I also read a cleansing, a washing away of the hunter's guilt that goes far beyond any complacent paw licking."

Left:
Fluff, *Prey Presto!* 1993. Installation, wool on carpet, 149 x 93cm.

93

Above:
Radar prepares a mouse for one of her nocturnal installations. These sometimes involve the use of stairs to create interesting spatial juxtapositions.

Installations involving dead animals or parts of dead animals have had an unfortunate history of misunderstanding. The human intolerance of rodents in particular, and a revulsion of unskinned or unplucked animal bodies in general, has resulted in the destruction of many valuable feline works using these forms. Worse still, the numerous cats who choose to express themselves by carefully displaying these 'tokens of life' in the home, where they can best be appreciated and protected, are admonished for their efforts and, as a result, discouraged from pursuing the only line of creative endeavor they know.

By bringing dead, or nearly dead prey back to the center of their territory, many cats are simply making a reciprocal gesture—leaving freshly killed food in return for the food they have been given by their owners. However, there are a growing number of cats, both male and female, who reportedly go to great pains to arrange and rearrange these small carcasses

or sections of carcass, with so much care and precision over such a long period of time, that the resulting designs can be none other than well-considered forms of artistic expression.

Radar, a seven-year-old Black-tipped British Shorthair female who lives in Santa Monica, has benefited greatly as a result of her owners' enlightened encouragement. Over the last three years, they have compiled an impressive photographic record of all her works, including a video (that she never tires of watching) of a kinetic installation in which a wingless dragonfly interacts with an almost lifeless shrew—a disturbingly poignant work that at times boarders on the profane. Unlike other well-known 'live' installationists who also use inanimate objects—Bully in Seoul (knitting needles and fish), or Moro in Milan (cardboard dolls and snails), Radar works exclusively with animate, or once-animate, objects. Her installations are meticulously constructed over a period of days, each piece being delicately patted into a variety of revealing positions until the relationship between all the elements has been thoroughly explored.

Reviewing a photographic exhibition of Radar's installations, critic John Ribberts wrote, "Of all her works, I was most deeply touched by the least complex, *Infra-mice* (left), a beautifully balanced and peaceful arrangement of two dead mice who seem to float together on a calm gray ocean. Their tiny bodies, wet and dishevelled, merge together as if swept along by some powerful force, yet only their heads join—a union of spiritual intent, a brief harmony of vision that is made all the more painfully real by the wide gulf that opens between their bodies and long flowing tails. Radar shows a fascination here with the inevitability of separation and the corresponding need to struggle for contact. The problem is how to achieve this without surrendering that deep sense of feline independence the artist must feel in her innermost being."

Left:
Radar, *Infra-mice*, 1994. Temporary installation, lounge carpet, 13 x 12cm. Santa Monica. Thanks to her owners' enlightened encouragement, Radar's meticulous constructions with 'stabilized' life forms now show a great maturity and clear sense of purpose.

ACKNOWLEDGEMENTS

Planning, research, writing and photography for this book have taken the best part of seven years to complete. We are deeply indebted to the many people who have given so generously of their time and knowledge during this period.

Our special thanks go to the numerous cat owners and members of cat art societies all over the world who gave us access to their photographic records and allowed us to observe and photograph their cats at work. In particular we would like to mention; Lynda Aitken, Mrs. Andersen, Val & Kevin Ball, Robert & Michelle Barge, Bob Barge, Liz Beasley, Anna Bell, Gael Binns, Jacqui & William Bonne, Sue Bradley, Rose & Fred Brittain, Beverley Brown, Dawn & Donna Burgess, Polly Buring, Mrs. & Lynda Coogan, Bill, Arja & Bran Davis, Lyn Davis, Sofia di Baci, Mrs. Chris Franklin, Margaret Gough, Sheldon Gunn, Gwenyth & John Halson, Jo & Murray Hedges, Hilma Hultenburg, Lorraine Kef, Edith Kern, Miri King, Berryl Lewis, Sandee Lidbetter, Nora Mann, Larry & Agnes Martin, Colin McCahon, Pam Nathan, Alli, Clive & Phyll Payton, Ginny Rastall, Maizy Reece, Margaret & John Ridge, Denise & Guy Sandle, Lorna & Don Simpson, Mrs. Stein, Jane Standenburg, & Ellie Taylor.

In particular, we wish to acknowledge the assistance we received from the Iris Mary Davies Memorial Trust, without whose generous contribution this book would not have been possible. Iris Mary Davies was the first person to suggest that human thought may be the crucial trigger in stimulating cats to begin marking with paint. Her clear, uncomplicated observations pre-dated the first scientific publication of the theory of inter-species morphic resonance by more than five years.

In a letter to a friend in 1976 she wrote,

.....so once I'd sent you Tiger's paintings and you'd seen them for yourself, you knew for sure that cats could paint. Now maybe that knowledge, that certainty that some cats can paint, created a type of positive force that started your lovely Blackie off doing it too. You see, I think it has to be something more than some energy field created by my cat doing something new here, that somehow made your cat, sixty miles away, all at once start doing the same thing. If it was like those monkeys you mentioned that suddenly started to wash their potatoes just after other monkeys on another island learned to do it, then why did it take Blackie two years to start painting? Why did he begin just after I posted you Tiger's pictures and why hadn't a cat around here begun to paint too? I'm convinced it was your knowing the possibility of cats painting, created an energy that was a kind of starter for your cat. Like water for a seed that's been dormant in the desert for years.

It is hoped that the wealth of feline creativity contained in these pages will stand as a tribute to Iris Mary Davies, and go some way in furthering her vision of a world in which animals are truly our partners.

SELECTED BIBLIOGRAPHY

In addition to articles and books noted in the text, this list contains both titles of a general nature and more academic works for those who wish to read in detail about particular topics mentioned in this volume.

ARK, P. 1992. **Copy Cats**. *Evidence of Representational Invertism in Feline Territorial Demarcation Activity.* Varnadoe & Kirk, NY.

ARORA, D. **Psychedelicacy**. The Effects of Catmint on the Creative Behaviour of Domestic Cats on Long Island. *Cat Art Today,* Vol. II 1992.

BALL, H. 1992. **Paws for Thought.** *The Magic & Meaning of Litter Tray Relief Patterns.* Slive & Seymour, Cambridge.

BORG. G. 1982. **The Bark Scratchings of Northern Australia**. McMahon University Press, Darwin, 1990.

CIACOMETTI, A. 1989. **Forget the Cat, Save The Art**. *A Reappraisal.* Raspail Schwitters & Prat, Lyon.

COVERT, J. **Alley Art**. *Bad Cats Do Their Stuff.* Dryfhout Press, New Hampshire.

DENIS, M. 1989. **More Paw Less Claw**. *Helping Your Cat Develop a Better Technique.* Order Press, New York.

FOGLE, B. 1991. **The Cat's Mind**. Pelham Books, London.

HERGOTT, E. (Ed.), 1993. **The Cat Artists Index**. *A Biographical Index of American Painters & Scratchers.* Flex Books, Boston.

LARSEN, K. 1987. **Understanding Art Writing.** *A Reader's Dictionary.* Kimmelman Reference Library, New York.

LONG, R. 1990. **Feline Artistic Potential**. *Stretching Your Cat Creatively.* Knight & Christopher, Los Angeles.

LORD-OSIS, J. **Pawnography**. Paw marking as a mode of sexual communication amongst domestic cats in Sweden. *Journal of Applied Aesthetics,* Vol. VI, 1991.

LUKAX, A. 1987 **Felineistine**. *Destructivism & the New Feline Aesthetic.* Pagan Books, Boston.

LUXE, C. **Matisse at Beaurivage**. A dissertation on exact easel positioning as it relates to possible points of harmonic reasonance. *New Cat Art,* Vol. III, 1992.

MARANDEL, J. 1986. **Pawtrayals & Pawtents**. *Cat Marks and Their Secret Meanings.* Crystal Arts, Berkeley.

MORRIS, P. 1962. **The Language of the Tail**. Fulica Press, Ascot.

MUTT, R. **Decorative Retromingency**. Urinary embellishment as a major problem in the curation of feline art. *Journal of Non-Primate Art,* Vol. XV, 1991.

PALETTIE, P. 1983. **Cross-Breeds, Criticism & Curation**. *A Complete Guide to Cat Painting.* Buhler & Lynes, Baltimore.

ROSENBLOOM, R. 1990. **Persian Art & Craft**. Bothmer & Bernard, New York.

SIVINTY, L.N.& P.T. 1972. **Udjat Cat**. *An Epistemology of Cat Marking in Ancient Egypt.* Umbawarrah University Press, Perth.

TANCOCK, J. 1988. **La vie et l'œuvre de Minnie Monet Manet**. Rosenberg & Schnapper, Paris.

WUNDERLICH, R. 1993. **Why Dogs Don't Paint**. Da Costa & Kaufmann, Princeton.